NOTABLE
SOUTHERN CALIFORNIANS

in

BLACK HISTORY

Robert Lee Johnson

THE
History
PRESS

Published by The History Press
Charleston, SC
www.historypress.net

First published 2017

Manufactured in the United States

ISBN 9781626195813

Library of Congress Control Number: 2016950696

Notice: The information in this book is true and complete to the best of our knowledge. It is offered without guarantee on the part of the author or The History Press. The author and The History Press disclaim all liability in connection with the use of this book.

CONTENTS

CONTENTS

ACKNOWLEDGEMENTS

I can think of many people who have been generous with their time, assistance and encouragement, but the one on whom I relied the most is my wife, Karani Marcia Johnson. She lost me for almost two years—I was here but I was not here, as I was usually lost in research on this book and was not able to provide her with my presence or my companionship. But she was still encouraging and helpful and, most importantly, understanding. I thank her with all of my heart. I also would like to thank Mr. Charles Matthews, the nephew of Miriam Matthews and the trustee of her collection. He is a kind and generous man who is deserving of the great responsibility that his aunt has placed on him. I would like to thank George Davis, executive director of the California African American Museum (CAAM), for his help. I would like to thank Ben Gibson of The History Press for his patience and guidance; my son, Devin Cole Johnson; my twin granddaughters, Aaliyah Gaynelle Johnson and Alisa Loretta Johnson, who I am going to visit as soon as I'm finished with this book; my stepson, Nissan Thomas; his partner, Ayana Chapman; and my newest granddaughter, Eden Brook Thomas. May you all go boldly into the future enriched by the knowledge of our past.

INTRODUCTION

The history of California does not fit neatly into the American narrative. It is a conquered land, having been won in the Mexican-American War of the 1840s that ceded most of the Southwest to the United States in a fulfillment of the imperialistic dream of Manifest Destiny, which was the true motivation for the war. On January 13, 1847, Lieutenant Colonel John C. Frémont and Mexican general Andrés Pico, the brother of Mexican California governor Pio Pico, signed the Treaty of Cahuenga, which ended the fighting in Alta California. During the war, most of the resistance to the American invasion of Mexican California took place in Southern California. The Battle of San Pasqual made Andrés Pico a military hero and eventually led to his promotion as head of the remaining Mexican forces. Under the Treaty of Cahuenga, the residents of the conquered Mexican state of Alta California could keep their lands and retain their language.

Unfortunately, even before California became a state in 1850, powerful American interests and their politicians sought to undermine the treaty. One of California's first senators, William Gwin (the other senator being former lieutenant colonel John C. Frémont), established the land commission that put the burden of proof of ownership on the families of the grantees of Spanish and Mexican land grants. This former Mississippi senator, who was now the senator from the new state of California, also authored bills that denied nonwhites the ability to seek redress against white men in court, making it that much easier for the new American politicians and businessmen to line their pockets at the expense of the old order. From 1850 to 1880, there was a huge transfer of wealth from the old order of Californio landowners to the new American settlers. By

1890, the California that existed before 1850 was becoming a quaint, romantic myth, populated by descendants of "pureblood" Castilian Spaniards who were not "tainted" by Moorish blood and accepted American rule with open arms.

Contrary to the myth, the fact was that men and women of African descent had settled into California as early as 1769. At the end of the Mexican-American War, some of the largest landowners in the state were of African descent. The mythical "Zorro" was most likely based on Don Solomon Pico (a man of African descent and cousin of Don Pio Pico), who became an outlaw and resisted the American occupation after the war. The Solomon Hills, adjacent to the city of Santa Barbara, are named for him.

By the 1890s, most of these Californio landowners had lost their land to American squatters, predatory lenders, taxes and theft. At the same time, formerly enslaved Africans in the United States sought new opportunities in California. Bridget "Biddy" Mason, a formerly enslaved real estate investor and philanthropist, was known to converse with Don Pio Pico over lunch at his "Pico House" Hotel on Main Street. (The hotel is still standing at the south end of Olvera Street.) I'm sure they must've had some very enlightening conversations. Don Pio Pico spoke no English, but Bridget "Biddy" Mason spoke Spanish and was able to incorporate his advice into her daily business dealings. Her grandson Robert C. Owens would become one of the wealthiest men in Los Angeles in the early twentieth century and a philanthropist in his own right with his financial support of Colonel Allen Allensworth's vision of a "Tuskegee of the West," which became the Black township of Allensworth.

The Black community's struggle for equality in California can be traced back to the Colored Conventions Movement of the 1850s, the National Association for the Advancement of Colored People (NAACP), Marcus Garvey's Universal Negro Improvement Association (UNIA) and the Women's Political Study Clubs of the early twentieth century right up to the establishment of the Black Panther Party in 1966. The city of Compton, California, elected the first Black mayor of a major municipality west of the Mississippi in 1969 and had a majority Black school board and city council. By 1973, Mayor Tom Bradley had become the first Black mayor in the modern era of Los Angeles, California, the second-largest city in the United States.

The aim of this book is to highlight a few of the stories of some of the amazing people who contributed greatly to Southern California but are not often heard about. I hope by reading these profiles that the reader will become curious and want to know more about these and the many other unsung heroes and become inspired to carry their torch into the future.

–R.L.J.

BLACK PIONEERS IN SPANISH CALIFORNIA

In the year 1510, Spanish author Garcia de Montalvo wrote Las Sergas de Esplandian (The Deeds of Esplandian), *an epic novel about Spanish chivalry. One of the fictional characters in the popular story was Queen Calafia, the courageous leader of a race of Black Amazons. In the book, she is described as the most beautiful of a long line of Queens who ruled over California, a mythical island. Calafia and her women warriors were said to wear gold armor adorned with many precious stones.*
–from the book Women Trailblazers of California

LUIS MANUEL QUINTERO

In late June 1542, Juan Rodriguez Cabrillo, who had been ordered by the viceroy of New Spain, Antonio de Mendoza, to explore and map the northern Pacific coast, was sailing north, leaving behind the shipyards at Barra de Navidad, New Spain, to begin his journey of exploration along the coast of Alta California. Two years earlier, Cabrillo and his fleet of three ships—the *San Salvador* (his flagship), the *La Victoria* and the *San Miguel*—began the first leg of their journey as they set sail from Acajutla, El Salvador. Barra de Navidad was the last Spanish naval outpost on the Pacific northern frontier.

On October 7, 1542, Juan Rodriguez Cabrillo and his fleet of three ships reached what we know today as Santa Catalina Island. Cabrillo named

More than half of the founders of the city of Los Angeles were of African descent. This image depicts Luis and Maria Quintero, founding settlers of the city of Los Angeles, who were of African descent. Their granddaughter owned the land grant that would later become the site of the city of Beverly Hills, California. *Miriam Matthews Collection, UCLA.*

the island San Salvador after his flagship. The next day, the fleet of three ships sailed into what we know today as San Pedro, the site of Los Angeles Harbor. Juan Rodriguez Cabrillo named the site "Baya de los Fumos." The next day, they anchored and spent the night in what is today's Santa Monica Bay. Sixty years later, Sebastian Vizcaino commanded a fleet of three ships as they explored the northern Pacific coast in search of safe harbors for Spanish galleons returning from the Philippines to Acapulco, New Spain.

It wasn't until 1769 that an overland expedition mapped what we know today as Southern California. The Portolá Expedition of 1769 included a soldier named Santiago de la Cruz Pico, whose grandson would become the last governor under Mexican rule in California, Governor Pio Pico. The Portolá Expedition would go as far north as the San Francisco Bay. Juan Batista de Anza's expedition into what we now call California began on January 8, 1774, from the Spanish colonial town of Tubac, south of present-day Tucson, Arizona. He arrived at the Mission San Gabriel on March 22, 1774. Soon De Anza was leading another expedition that included colonists who arrived at the Mission San Gabriel in January

1776 after traveling what would become known as the Juan Batista de Anza National Historic Trail.

In January 1781, Captain Fernando Rivera y Moncada was ordered to escort a group of settlers from Sonora, New Spain, to the Mission San Gabriel in Alta California. These settlers would become the founders of what would become the second-largest city in the United States. According to the esteemed historian/librarian Miriam Matthews, of the forty-four original settlers of Los Angeles, twenty-six were Black, sixteen were Indian and two were white. Luis Quintero, the son of an enslaved African, and his wife, Maria, who was also of African descent, were among the forty-four original settlers of what would become the city of Los Angeles, California.

Known as Los Pobladores (the Settlers), they arrived at the Mission San Gabriel traveling from Alamos, Sonora, New Spain. On September 4, 1781, the forty-four Pobladores left the Mission San Gabriel, accompanied by two priests and a military escort, to settle on a town site nine miles away from the mission that had been located and mapped by Father Juan Crespi, a Franciscan missionary who was part of the 1769 expedition that included Father Junipero Serra and was led by Gaspar de Portolá. The name of the town site was El Pueblo de la Reina de Los Angeles.

Luis Manuel Quintero was the most unlikely of settlers. He was not a soldier or a farmer; in fact, he was a tailor, and at age fifty-five, he was one of the older pioneers in the group. It has been said that Luis Quintero was the last person to sign on to the expedition. It is believed that the motivating factor was that three of his daughters had married soldiers who were assigned to the expedition; the rest of the family had signed on to be close to them. Whatever the reason, Luis Quintero and his family joined the other pioneers in search of new opportunities on the northern frontier. Luis Quintero's sons-in-laws—José Fernandez, Joaquin Rodriguez and Eugenio Valdez—were eventually stationed at the Santa Barbara Presidio along with their new wives. In 1782, Luis Quintero and his family left Los Angeles for Santa Barbara, where he served as the master tailor at the Presidio. Luis Quintero died in 1810 in Santa Barbara, but his legacy lived on in his descendants, including his granddaughter Maria Rita Valdez Villa, who received the original land grant for the area that we know today as Beverly Hills, Rancho Rodeo de las Aguas (Ranch of the Gathering Waters), and Eugene Biscailuz, who would become sheriff of Los Angeles County and a founder of the California Highway Patrol.

Over the years, there've been efforts to whitewash the history of the city of Los Angeles by denying its Black roots. Starting in the 1950s, a plaque that was installed in El Pueblo de Los Angeles State Historic Park paying

tribute to the founders of the city listed the names and race of the eleven families who founded the city of Los Angeles. Not long after that plaque was erected, it disappeared. It was replaced twenty years later with a plaque that listed the city's founders without mentioning their race. But in 1981, during the city's bicentennial, due to the vocal efforts of Miriam Matthews, the city of Los Angeles's first Black librarian, a new plaque was installed detailing the names, race, genders and ages of the pioneering settlers who founded the city of Los Angeles, making it apparent that more than half of the founders of the city of Los Angeles, like Luis Manuel Quintero, were of African descent.

JUAN FRANCISCO REYES

The section of the city of Los Angeles known as the San Fernando Valley transformed from an agricultural community in the early twentieth century to a booming patchwork of bedroom communities supported by the movie industry and high-tech manufacturing dominated by the aerospace industry in the latter half of the twentieth century.

Most of the cities in the "Valley" were racially segregated by custom even after racial covenants were found to be unenforceable by the United States Supreme Court. The only exception was the city of Pacoima. It wasn't until the 1970s and '80s that progress was made on the issue of fair housing in the bedroom communities of the "Valley."

These facts about the San Fernando Valley in the twentieth century become most ironic when we understand the background of the first grantee of the land grant that would become the San Fernando Valley. Juan Francisco Reyes was born between 1745 and 1749 in Zapotlan El Grande Jalisco and died on November 8, 1809, at Mission San Gabriel. He was the son of José Diaz and Gertrudis Reyes. In 1769, Reyes found himself one of the early settlers of San Blas, Nayarit, where he found work building ships that were to supply new settlements in Alta California. In 1771, Juan Francisco Reyes joined the army and was stationed at Monterey and San Antonio in Alta California, according to William Mason, associate curator of California history at the Los Angeles County Museum of Natural History. Another account suggests that Juan Francisco Reyes was a soldier as early as 1769 and participated in the Portolá Expedition to Alta California in that same year, accompanying Father Junipero Serra, the founder of the mission system in Alta California,

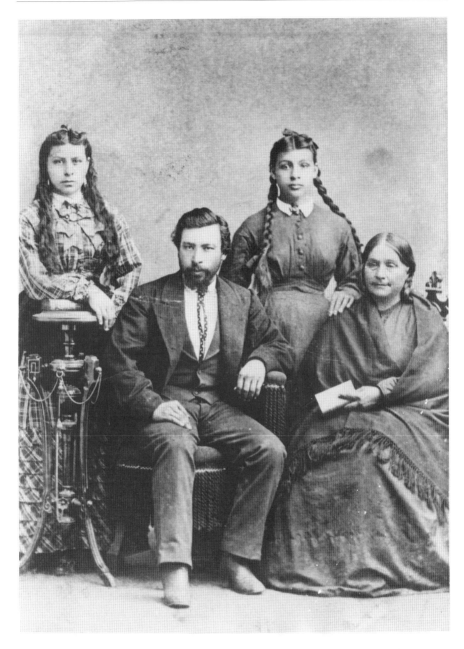

Isidro Reyes Jr., the great-grandson of Juan Francisco Reyes, first grantee of the San Fernando Valley, acknowledged as the first Black mayor of Los Angeles, with Margarita Reyes (great-granddaughter), Francisca Reyes (great-granddaughter) and Antonia Villa de Reyes (widow of Isidro Reyes Sr.). Juan Francisco Reyes was the first mayor of Los Angeles of African descent and the owner of a land grant that included much of today's San Fernando Valley. *Miriam Matthews Collection, UCLA.*

where he was stationed at Monterey and later at San Antonio.

In January 1782, Juan Francisco Reyes married Maria Luisa del Carmen Dominguez at the Mission San Gabriel. Their union was blessed with four children. In 1787, Juan Francisco Reyes, after serving the Spanish Crown for many years from Monterey to San Diego, decided to retire from the army and moved his family to Los Angeles. In about 1785, Reyes had received a land grant from the Spanish Crown that became known as the Rancho Encino at San Fernando, where he raised horses and cattle. He held that land grant until 1797, when the Mission San Fernando was established and the Catholic Church took over the land grant. The Reyes ranch house was converted into a home for the pioneering padres of the soon-to-be-built Mission San Fernando. Reyes eventually received another land grant near the modern community of Lompoc, California.

In 1845, Andrés Pico (the last military leader of Mexican California), the brother of Pio Pico (the last governor of California under Mexican rule), was leasing the rancho at the former Mission San Fernando. In 1853, Andrés Pico acquired an undivided half interest, splitting the former Mission San Fernando in half along what is now Roscoe Boulevard and taking the southern half, while Eulogio de Celis took the northern half. After falling into financial difficulty, Andrés Pico sold his southern half interest to his brother, Pio Pico, in 1862. In 1869, Pio Pico sold most of his interest in the San Fernando Valley to Isaac Lankershim to raise money to build the Pico House, which still stands on Main Street just south of Olvera Street. The San Fernando Valley, just like the rest of Los Angeles, has historic Black roots.

Juan Francisco Reyes was a well-respected citizen of early Los Angeles. This man of African descent became the *alcalde*, or mayor, of the Pueblo of Los Angeles from 1793 to 1795 and is generally recognized as the first Black mayor of Los Angeles 180 years before Mayor Tom Bradley.

Maria Rita Valdez Villa

Beverly Hills, California, is known around the world as the home of the rich and famous—movie stars, swimming pools and, unbeknownst to most people, Black roots.

The Gaspar de Portolá Expedition of 1769, following a Native American trail that would one day become Wilshire Boulevard, came upon "a large vineyard of wild grapes an infinity of rose bushes," according to Friar Juan

Crespi, a member of the expedition. August 3, 1769, was the first time Europeans had set foot on the land that was sacred to the Native Americans and known as the "Gathering of Waters." The land was so named because of the creeks that emptied into the area from the canyons above what we know today as Coldwater Canyon (Canada de las Aguas Frias, or Glen of the Cold Waters) and Benedict Canyon (Canada de los Encinos, or Glen of the Green Oaks), making the land fertile and ripe for farming and raising cattle.

In 1838, the governor of Mexican California deeded the land grant called "Rancho Rodeo de las Aguas" (Ranch of the Gathering Waters) to the widow of a Spanish soldier, Maria Rita Valdez Villa. She and her husband in 1828 had settled on 4,500 acres of land that would one day be known as Beverly Hills.

Maria Rita Quintero Valdez was born on May 21, 1791, and was baptized on May 24, 1791, at the Mission Santa Barbara. She was the granddaughter of Luis Quintero, one of the original settlers of the city of Los Angeles. A tailor by trade, Quintero was the son of an enslaved African. Maria Rita Quintero Valdez married Vicente Ferrer Villa on February 16, 1808, at the

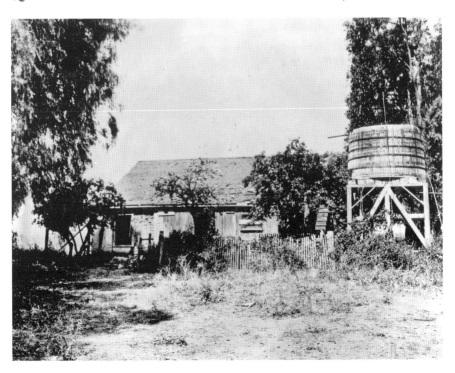

Maria Rita Valdez Villa's Adobe ruins in what is now the city of Beverly Hills, California. *Miriam Matthews Collection, UCLA.*

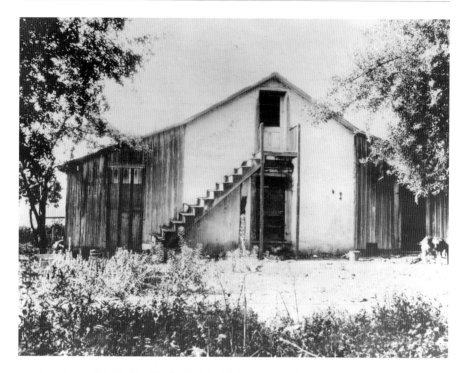

Another view of Maria Rita Valdez Villa's Adobe ruins, which had served as the headquarters of her land grant "Rancho Rodeo de las Aguas" (Ranch of the Gathering Waters). *Miriam Matthews Collection, UCLA.*

Mission San Gabriel. He died in August 1828, leaving behind Maria and three young daughters: Josefa Antonia, Juana Villalobo and Maria Del Villa. Maria, now widowed, had a ranch to run. She built her home at what is now Alpine Drive and Sunset Boulevard, and once a year, she hired extra vaqueros to bring in her herd of cattle at a rodeo that she held under a giant eucalyptus tree that is now the corner of Pico and Robertson Boulevards.

Following the Mexican-American War, Mexican landowners had to prove to the American government—represented by a three-man public land commission—that they legally owned the land where they had been living. Maria Rita Valdez Villa filed with the public land commission in 1852. The grant was patented to her in 1871, seventeen years after her death. In 1852, she survived an attack and siege on her rancho by what was reported to be three "Native Americans." In 1854, she sold her ranchero to land speculators Henry Hancock and Benjamin Wilson for $4,000. She died later that year in Los Angeles, California.

PIO PICO AND ANDRÉS PICO

Even though cities, streets, libraries, schools, parks and the proposed "Pio Pico" energy center in Otay Mesa bear their name, very few people know the story of the Pico brothers, Pio and Andrés, and how these two men of African descent shaped the history of California. At one time, the politically influential Pico brothers were among the largest landowners in California.

The Pico family roots in California run very deep. In 1775, José Maria Pico and his future wife, Maria Estaquia Gutierrez, arrived in California with their parents as part of the De Anza Expedition. José Maria Pico followed in his father's footsteps, becoming a soldier of the Spanish Crown, and was stationed at the Mission San Gabriel. José and Maria Pico had sons José, Pio and Andrés. They had daughters Concepcion, who married Domingo Carrillo; Estefana and Jacinta, who were married to José Carrillo (at different times), the brother of Domingo; Ysadora, who was married to John Forster; Tomasa, who married into the Alvarado family; and Feliciana.

On May 5, 1801, Pio de Jesus Pico was born at the Mission San Gabriel Archangel. In 1805, the Pico family moved to San Diego, where their father, artillery sergeant José Maria Pico, served as a soldier at the San Diego Presidio. Andrés Pico was born in San Diego on November 18, 1810. Sergeant José Maria Pico and his family returned to the

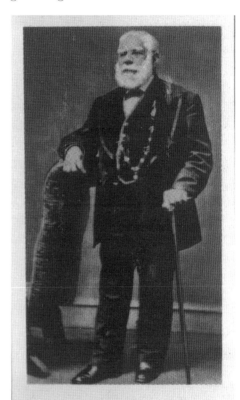

Don Pio Pico, twice governor of California under Mexican rule, as he appeared as a dignified old man long after California joined the United States.

Image depicting Governor Pio Pico as an elderly man. *Miriam Matthews Collection, UCLA.*

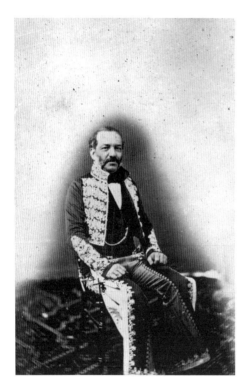

General Andrés Pico, the hero of the Battle of San Pasqual, the last military leader of Mexican California and brother to Governor Pio Pico. *Miriam Matthews Collection, UCLA.*

Mission San Gabriel Archangel, where he died in 1819. Upon their father's death, and with their elder brother, José, serving in the military, Pio Pico took over as head of the family. He moved the family to San Diego, where he set up a small shop and employed his mother and sisters as seamstresses. In 1821, he opened another small shop in Los Angeles selling drinks for "two bits." By 1824, he was able to build a house for his family in old San Diego.

Pio Pico soon became involved in politics. In 1826, Pio Pico was elected to the advisory assembly of the governor. By 1832, he had become the senior vocal of the assembly. In that same year, Pio Pico led a revolt against Governor Manuel Victoria (a man of African descent), who was appointed to the governorship by the government in Mexico City. Governor Victoria proved to be a very unpopular governor. He abolished the town councils and would not convene the assembly. He also imprisoned anyone who opposed his rule. He was especially unpopular among the wealthy landowners in California because of his refusal to secularize the missions, keeping some of the best land in the possession of the church. The opposing forces met near the Cahuenga Pass on December 5, 1831. The battle ended with Governor Victoria being seriously wounded and fleeing back to Mexico City. This left the governorship open, and as senior vocal of the assembly, Pio Pico became governor of California. Governor Victoria's hand-picked successor challenged Governor Pico's claim to the office, resulting in his administration lasting only twenty days. But within a year and a half, the missions were being secularized, and vast tracts of some of the most coveted land in California would become available to private landowners. Pio Pico was now a leading political figure in California. By the

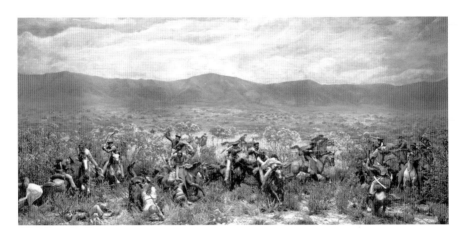

A diorama depicting the defeat of American troops under General Kearney at the hands of the Californio militia under the command of Captain Andrés Pico at the Battle of San Pasqual. *Miriam Matthews Collection, UCLA.*

late 1830s, Pio Pico and his brother Andrés Pico, who was also a member of the assembly, were leaders in the rebellion against Governor Alvarado. They were imprisoned several times, but because of their influence and cunning, they were able to escape. In 1834, Pio Pico married Governor Alvarado's niece, Maria Ygnacia Alvarado.

In 1845, Pio Pico, at the insistence of the former governor Juan Alvarado and with the support of his brother Andrés, led a popular revolution against the sitting California governor Manuel Micheltorena. This victory led to Pio Pico's rise to the governorship for a second time. His administration would last until the invasion of California by the military forces of the United States of America. In July 1846, Governor Pico convened a meeting of the California Assembly and asked it to authorize him to take command of the military forces in order to resist the invasion of California by the United States. The assembly instead directed Governor Pico to leave the country to avoid capture and appeal to Mexico City for military aid.

Governor Pico's brother General Andrés Pico was in command at the most significant battle that took place in California during the Mexican-American War, the Battle of San Pasqual. San Pasqual is southeast of Escondido and, at the time of the battle, was a Native American campsite. In the early morning hours of December 6, 1846, the United States Army under the command of General Stephen Watts Kearney engaged a smaller force of Californio Lancers under the command of

Andrés Pico and was defeated. José F. Palomares, one of General Pico's Lancers at the battle, recalled, "With our lances and swords we attacked the enemy forces, who could not make good use of neither their firearms nor of their swords....We did not fire a single shot, the combat was more favorable to us with our sidearms [swords]. Quickly the battle became so bloody that we became intermingled one with the other and barely were able to distinguish one from the other by voice and by the dim light of dawn which was beginning to break." It was reported that nineteen U.S. soldiers were killed in the battle, with twelve wounded, including General Kearney. Andrés Pico's forces reported twelve wounded and one captured. This victory was the high point of Californio military resistance during the Mexican-American War.

On January 13, 1847, after a series of battles that led to the American reoccupation of Los Angeles, General Andrés Pico, the brother of Pio Pico, the last governor under Mexican rule, became the last military leader of

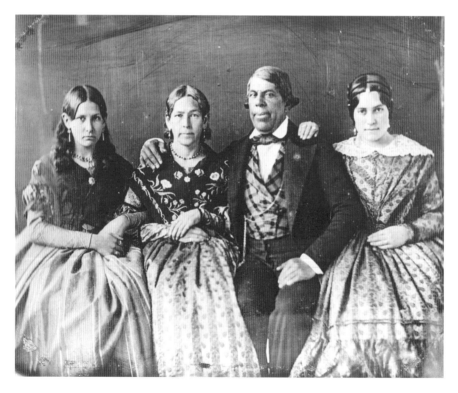

Governor Pio Pico pictured with his wife and nieces in the early 1850s soon after the American takeover of California. At this time, he was one of the largest and wealthiest landowners in California. *Miriam Matthews Collection, UCLA.*

The Adobe ruins of Governor Pio Pico's home in what is now Whittier, California. *Miriam Matthews Collection, UCLA.*

Mexican California as he signed the Treaty of Cahuenga, with Lieutenant Colonel John C. Frémont representing the United States of America, ending hostilities in California.

With the end of the war, the Pico brothers returned to civilian life as ranchers and businessmen. In the late 1860s, Pio Pico sold most of his vast holdings in the San Fernando Valley to build the Pico House. In 1870, the Pico House was the most luxurious hotel in Los Angeles. Andrés Pico had taken up residence at the Mission San Fernando and converted the spacious *convento* into a grand hacienda where he entertained his guests lavishly. The Pico brothers owned rancheros in San Diego County, Temecula, Whittier and La Habra, as well as Ranchero Los Coyotes in what is now Long Beach and the Santa Margarita and Las Flores Rancheros, which included the present-day Camp Pendleton and surrounding areas and properties as far north as Sacramento County with the Ranchero Arroyo Seco. In Santa Clarita, the Pico brothers owned Pico Canyon, where they drilled for oil.

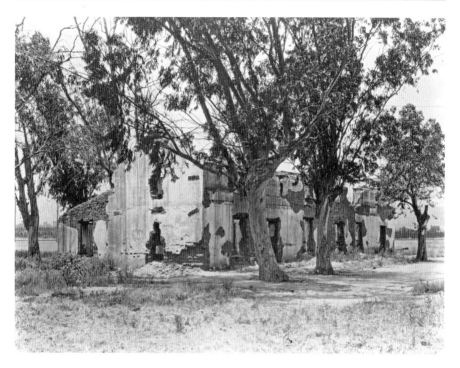

General Andrés Pico's Adobe ruins on the grounds of mission San Fernando in Los Angeles's San Fernando Valley. *Miriam Matthews Collection, UCLA.*

Andrés Pico represented the counties of Los Angeles, San Bernardino and San Diego in the California Senate in the early 1860s. Because of his military activity and the growing crime rate in Southern California in the 1850s, Andrés Pico was appointed general of the California militia known as the California Rangers. He was best known at that time for leading the posse in search of the notorious Flores-Daniels Gang in 1857. On February 14, 1876, Don Andrés Pico's badly beaten body was found at the doorstep of his townhouse at 203 North Main Street in Los Angeles. His brother, the former governor Pio Pico, spent a fortune trying to find out who had killed his brother. To this day, that mystery has never been solved.

After years of expensive litigation over land issues and water rights, dealings with unscrupulous lenders and a much celebrated trial over the ownership of the Ranchero Santa Margarita with his Yankee brother-in-law, John Forster, at the end of his illustrious life, Don Pio Pico was unceremoniously evicted at the age of ninety-two from his beloved "El Ranchito," in what is now the city of Whittier, a property he had owned

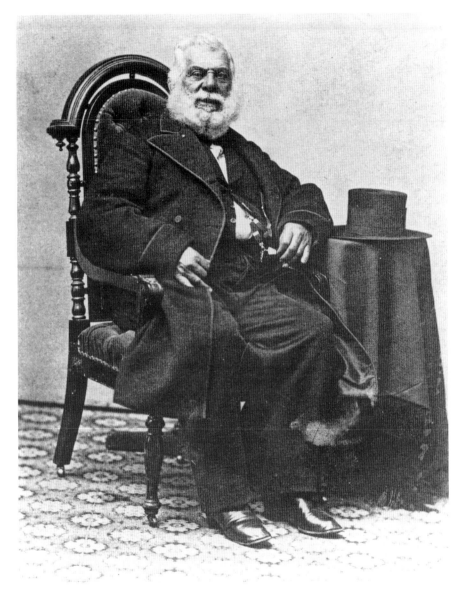

Don Pio Pico, last governor under Mexican rule and at one time one of the largest landowners in California. *Miriam Matthews Collection, UCLA.*

for over forty years, a victim of predatory lending and a racially biased court system. He passed away on September 11, 1894, at the home of his daughter in La Ballona, now known as Culver City, California.

UNCHAINED IN AMERICAN CALIFORNIA

*Find out just what any people will quietly submit to and you have the exact
measure of the injustice and wrong which will be imposed on them.*

—Frederick Douglass

Bridget "Biddy" Mason

The mysterious sudden death of President Zachary Taylor led to the
presidency of Millard Fillmore, who, unlike President Taylor, supported
the Compromise of 1850. Abolitionists were opposed to the compromise
because of the Fugitive Slave Law, which required the return of runaway
slaves to their owners under penalty of law. The fact that it allowed California
to come into the Union as a free state would have a greater effect on one
woman in particular.

The woman who would become known as Bridget "Biddy" Mason was
believed to be born on August 15, 1818, in either Hancock County, Georgia,
or in the state of Mississippi. As she was born a slave and separated from
her parents at an early age, the names of her parents are unknown. She
was only called by her first name, "Bridget"; her nickname, "Biddy," means
"servant girl." As a child, she was sold several times and worked on several
different plantations. While working on the John Smithson plantation
in South Carolina, she was given to John Smithson's cousins Robert and

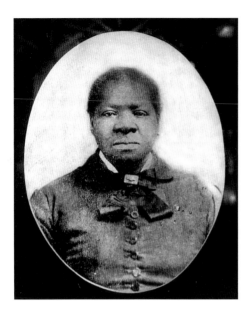

Photograph of Bridget "Biddy" Mason, former slave, wealthy landowner, businesswoman, philanthropist and founding member of First African Methodist Episcopal Church (FAME) in Los Angeles, the oldest Black church in the city. *Miriam Matthews Charitable Trust and African American Museum.*

Rebecca Smith, along with two other female house servants and a blacksmith, as a wedding present in 1836. She is believed to have been about eighteen years old. Even though she was forbidden by law to learn how to read or write, she became skilled in the use of herbs for medicinal purposes and midwifery; these skills made her all the more valuable to the Smiths.

Bridget's duties on the Smith plantation included caring for livestock, working the cotton fields and caring for the wife of the master; this included participating in the deliveries of the Smiths' six children. While working on the Smith plantation in Mississippi, Bridget had three daughters: Ellen, Ann and Harriet. It is believed that the slave owner Robert Smith fathered all three.

In the mid-1840s, Robert Smith became a member of the Church of Jesus Christ of Latter-day Saints (the Mormons). On March 10, 1848, Robert Smith, with his family and slaves, left with a group of Mississippi Mormons for Salt Lake City. Bridget's youngest daughter, Harriet, was only an infant. The two-thousand-mile trip took seven months. Bridget and the other slaves were made to walk behind the wagons and the livestock. Their jobs on the trip were to set up camp each evening and pack it up the next morning, cook, clean and tend to the livestock. Several children were born during the trip, and Bridget helped deliver them all.

Once in Salt Lake City, Robert Smith joined a group of Mormons who planned to establish a new settlement in San Bernardino, California. Bridget and the other slaves were once again made to walk behind the wagons and livestock from Salt Lake City to San Bernardino.

In 1851, the Lugo family sold the Rancho San Bernardino to a group of five hundred members of the Church of Jesus Christ of Latter-day Saints; the Mormons were led by Captain David Seeley, Captain Jefferson Hunt

and Captain Andrew Lytle. The Mormons relied on people like Black "Freeman" Robert Owens to supply them with lumber and other supplies to support their "Mormon stockade." It is believed that Robert Smith did not realize that in 1849, California drafted a constitution forbidding slavery and in September 1850 had joined the Union as a free state as a result of the Compromise of 1850. While in San Bernardino, Bridget made friends with several free Black people who informed her and the other slaves that they were in free territory and no longer had to be slaves. Charles Owens, the son of the successful businessman and land owner Robert Owens, had fallen in love with Bridget's daughter Ellen and had a vested interest in her being free.

With all this talk of freedom, the slave owner Robert Smith decided to travel to Texas, where he believed that he would be able to hold his slaves without question. The only problem was that Hannah, one of his slaves, was pregnant with his child and was not able to travel. So, he packed up his family and his slaves and tried to hide them in the Santa Monica Mountains until after Hannah gave birth. In the meantime, Charles Owens asked his father, Robert Owens, to intercede on behalf of Bridget's daughter Ellen and the other slaves. Owens contacted Los Angeles sheriff Frank Wyatt and devised a plan to rescue Ellen and the other slaves with the help of ten of Robert Owens's Black vaqueros. Sheriff Wyatt and Robert and Charles Owens led the posse into the Santa Monica Mountains, where they found Smith camped in a secluded canyon. The sheriff served Smith with a writ of habeas corpus and took his slaves into protective custody, escorted by Robert Owens's vaqueros to Santa Monica. In January 1856, Robert Smith's slaves found themselves in a courtroom before Judge Benjamin Hayes. Since Black people were not allowed to give testimony in open court, the judge questioned Bridget and her fellow slaves in his chambers. After questioning Robert Smith, who claimed that his slaves were merely his traveling companions, Judge Hayes became suspicious that these people were indeed Smith's slaves. Robert Smith did not return to court the next day, so on January 21, 1856, the Smith slaves were freed. This was a year before the infamous Dred Scott decision would've made their bid for freedom moot.

As a free person, Bridget took the surname Mason—no one is sure why. Bridget "Biddy" Mason found her first job with Dr. John Griffin and became a well-known midwife and herbalist. In 1862, during a smallpox epidemic, Bridget Mason became famous for ministering to the ill in the Los Angeles prisons. After years of saving her money, she purchased several lots along what were then the edges of the city of Los Angeles. These lots

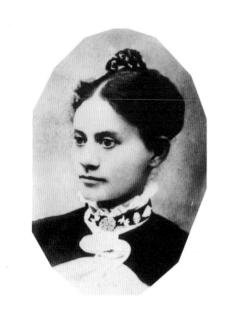

Mrs. Ellen Owens, wife of Charles Owens.
Miriam Matthews Collection, UCLA.

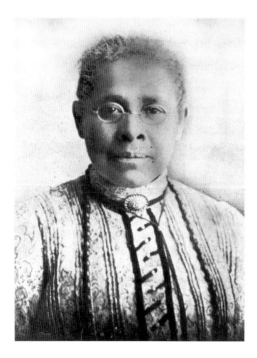

were along today's Spring Street and Broadway, two major thoroughfares in downtown Los Angeles. With the advice of Robert Owens, who owned a business and property along San Pedro Street along with the famed Owens Canyon (also known as "Nigger Canyon") in the San Gabriel Mountains, Bridget Mason became a shrewd investor in real estate and a successful businesswoman with a string of convalescent homes that she ran with her daughter.

During the 1880s, there was a flood that devastated the community. Bridget Mason, by then known to many as "Grandma Mason," set up open-ended accounts with the local grocer for those in need. Since Black children were excluded from public schools, Bridget Mason worked with others to found a school for Black students. She also worked with her friends to establish the First African Methodist Episcopal Church in the living room of her home. She later donated the land on which the church was built and paid the taxes and the minister's salary.

Mrs. Ellen Owens Huddleston, the remarried widow of Charles Owens and a businesswoman in her own right. *Miriam Matthews Collection, UCLA.*

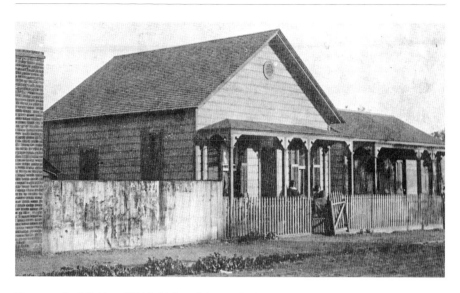

Photograph of Bridget "Biddy" Mason's home. *Miriam Matthews Collection, UCLA.*

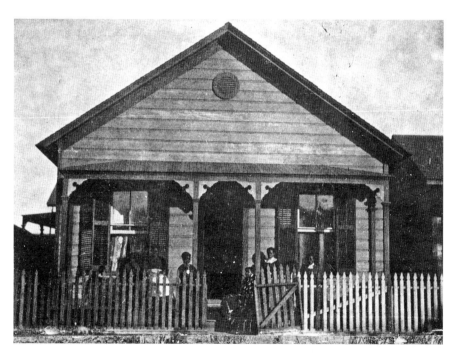

Photograph of Robert Owens's home, which he shared with the newly freed Mason family. *Miriam Matthews Collection, UCLA.*

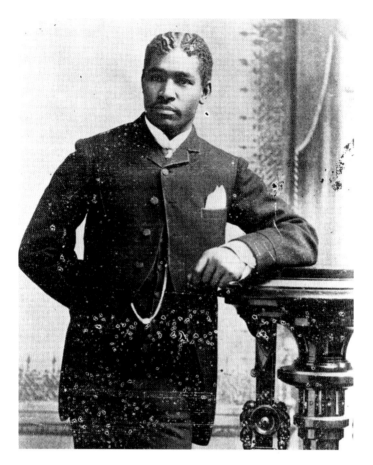

Bridget "Biddy" Mason's and Robert Owens's grandson Robert C. Owens, known for his prowess in the world of finance and for his support of Colonel Allen Allensworth's dream of a "Tuskegee of the West" that would be known as the town of Allensworth. *Miriam Matthews Collection, UCLA.*

Bridget Mason spoke fluent Spanish and was known to dine with the former governor of Mexican California Pio Pico at the Pico House on the plaza.

Born into slavery, separated from her parents at a young age and having endured rape and humiliating treatment at the hands of her slave owners, Bridget Mason was able to take control of her own life and prosper as a businesswoman, real estate investor and philanthropist. She was no longer "Biddy" the servant girl when she died on January 15, 1891. Bridget Mason was the beloved "Grandma Mason" to a whole community.

Nathan Harrison

In northern San Diego County sits the majestic Mount Palomar, reaching five thousand feet above sea level and offering spectacular 360-degree views of the inland desert and westerly views toward the ocean. Known for cool breezes, its mountain meadows and forests have long been a favorite of those who enjoy camping, picnicking, hiking and fishing. It is also the home of the Palomar Observatory, which operates several telescopes and is owned and operated by the California Institute of Technology. Financed with a $6 million grant from the Rockefeller Foundation, the Palomar Observatory was first used on January 26, 1949, by the imminent astronomer Edwin Powell Hubble. Astronomers using the observatory have been responsible for many groundbreaking astronomical discoveries.

Long before Mount Palomar was known for its astronomical discoveries, it was known as the home of a former slave turned pioneer named Nathan Harrison. He was commonly referred to as "Nigger Nate." He was known to his friends as Nate, and later in life, some called him Uncle Nate; it seems that he was never given the courtesy of being called Mr. Harrison. Nate

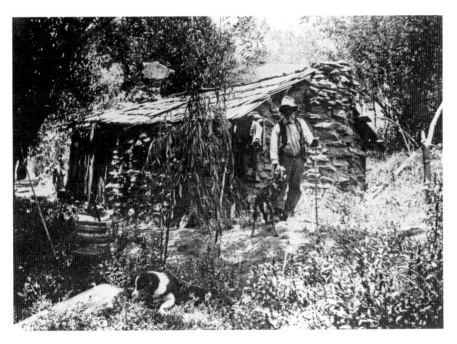

Nathan Harrison at his cabin on Mount Palomar, California, where he owned 160 acres that included two freshwater springs. *Miriam Matthews Collection, UCLA.*

Harrison lived on the west side of the mountain next to a steep grade that was built in the early years of the twentieth century. It was the only road into the Valley until the construction of the Palomar Observatory. For years, the road was known as "Nigger Nate Grade"; the offensive name was changed in 1955 at the insistence of the San Diego chapter of the NAACP to Nathan Harrison Grade.

Known for his kindness and his cheerful disposition, Nate Harrison would greet weary travelers with buckets of ice-cold water from one of two natural springs on his property. According to Robert C. Fleischer, Charles Mendenhall, who was a member of a family who settled on Mount Palomar, remembered Nathan Harrison as "smart as a whip, a good wrangler and a pretty good timber man." Adaline Bailey, a Palomar Mountain resident since 1913, met Nathan Harrison in 1911: "I remember he was always smiling and cheerful even near the end of his life. He had a joke. He said he was the first 'white man' on the mountain. He told the joke often and always got a laugh." This information was gathered from interviews of acquaintances of Nathan Harrison conducted by Robert C. Fleischer.

Many stories about how Nathan Harrison escaped slavery and came to California have been told, but it seems that no one knows for sure which story is true. What is known is that he arrived in California in the late 1840s during a time when the enslavement of Black people was a grim reality in the United States. The Fugitive Slave Law allowed for the legal kidnapping of Black people by slave hunters. I'm sure that if Nathan Harrison escaped the horrors of America's "peculiar institution," he was aware that he could be kidnapped and re-enslaved and was careful to keep his past to himself. The most likely story was that Harrison was a slave who was owned by a wealthy Virginia planter by the name of Lysander Utt, who came to California during the gold rush of the late 1840s. It is said that they arrived at the Merced Goldfields in late 1848; others say that they arrived in Los Angeles on Christmas Eve 1849.

It should be noted that in the late 1840s, before the American conquest, California was part of Mexico, which had outlawed slavery in the 1820s. In 1850, when California became part of the United States, it came into the country as a free state. It seems that Nathan Harrison found his way to the Pauma Valley and worked as a herdsman on one of the rancheros. He bought land and lived in Rincon before moving on to the west side of Smith Mountain, which would later be renamed Palomar Mountain in 1900. Nathan Harrison owned approximately 160 acres midway up the mountain. He built his cabin by two natural cold-water springs and what

was originally an Indian trail that would later become a steep, rough road that would bear his name. He raised and sold horses and other livestock, along with maintaining an orchard and a small garden. At the time when he settled on the mountain, his only neighbors were the local Native Americans who lived nearby. We can only imagine that Harrison must've felt that he was safe from slave catchers and free to live his life as he saw fit.

Sometime after the Civil War, Nate Harrison was walking along a trail when he came face to face with a white man named George Doane, whose family had recently settled on the mountain (Doane Valley). According to George Doane, Nate fell at his feet and begged him not to send him back into slavery. Mr. Doane did not understand what Nate was talking about; it seemed that Nathan Harrison did not know that the Civil War was over and he was as free as any other man and no longer had to fear being kidnapped back into slavery. George Doane and Harrison soon became very good friends.

Nathan Harrison lived for many years on the west side of the mountain next to the only road into the Valley. He would meet and greet travelers and allow the teamsters to water their horses at his trough full of ice-cold water from his natural spring. Later in life, he also provided water for automobiles as they labored up the steep grade and needed water to cool their overheated engines. For his services, he would receive money or sometimes food. He became well known to the local

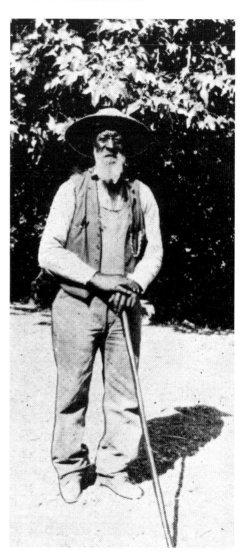

Former slave and landowner Nathan Harrison. *Miriam Matthews Collection, UCLA.*

33

people of San Diego, so much so that when the *Union* newspaper erroneously reported his death by drowning during a storm, the newspaper later made a retraction: "Nigger Nate is not drowned as was reported in the Union; he still lives to vote the Republican ticket [he was registered to vote in 1894] and beat his way through the world."

According to Robert C. Fleischer, "In the late summer of 1920 some friends on the mountain found Nate in his cabin in deep pain and they persuaded him to let them take him to the hospital in San Diego where he died on October 10, 1920. After his death, some friends collected money and a plaque was placed on a granite monument near the spring and his Stone house which read: Nathan Harrison spring. Brought here a slave about 1848 Diego (sic; Died) October 10, 1920. Aged 101. 'A Man's a Man for a' That.'" (This comes from the Robert Burns poem, written in 1795, calling for equality among all people.) Another account states that Nathan Harrison was taken to the San Diego home for the aged by county authorities while he begged to be left on the mountain. He soon became very ill. Wanting to die in familiar surroundings, he begged his friends to take him home, back to his mountain. He died on October 10, 1920. Three days later, on October 13, he was buried at the Mount Hope Cemetery paupers' field with no headstone. In 1972, Ed L. Diaz of the National Afro-American Historical Society organized an effort to collect donations to honor Nathan Harrison with a headstone. The headstone was furnished at cost by the owner of the Pyramid Granite Company, Phil Hoadley. Nathan Harrison will always be remembered as a pioneer in San Diego. Dewey Kelly, a Carlsbad rancher, came into possession of Nathan Harrison's land and later sold it to brothers Richard and Stuart Day.

Harrison's death certificate notes that his birthday was January 1, 1823, and that he was born in Kentucky.

ALLEN ALLENSWORTH

The cry was "up from slavery," and Booker T. Washington was the inspiration for a whole generation of formerly enslaved Black folk. Unlike Dr. W.E.B. Du Bois, Booker T. Washington believed that the Black community's salvation was not in challenging Jim Crow laws but in self-reliance and education. From his base at the Tuskegee Institute in Alabama, he organized a network of sympathetic businessmen and ministers in Black communities

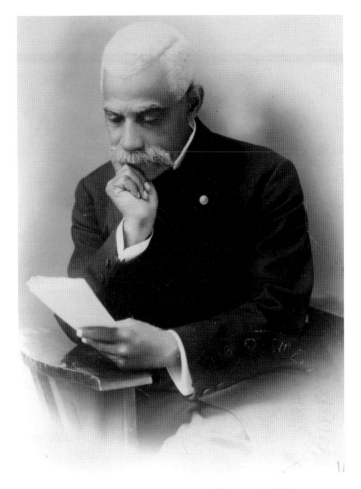

Colonel Allen Allensworth, in a contemplative mood. *Miriam Matthews Charitable Trust and African American Museum.*

throughout the United States. One of those men was Lieutenant Colonel Allen Allensworth.

Born into bondage on April 7, 1842, Allen Allensworth was the youngest of thirteen children who were sold off to various plantation owners. The Starbird family of Kentucky owned Allen and his mother, Phyllis, and assigned the young slave boy to be their son Thomas's "little nigger," as was the custom. When Thomas began school, Allen was encouraged by his mother to have "Master" Thomas play school with him every day when he came home. Both Allen and his mother knew the dangerous game that he was playing. If caught learning how to read and write, he could be killed or sold downriver, but his

mother believed that it was worth the risk. When the Starbird family realized that Allen was learning how to read, they sent him to live with another family, while his mother was sold to a neighbor as a cook.

After being sold a number of times, young Allen was bought by Fred Scruggs of New Orleans, Louisiana. While in New Orleans, Allen was taught how to be a jockey; he was soon doing so well that he began racing his master's best horse. In 1861, Allen's master brought Allen upriver for the fall meet in Louisville, Kentucky. While in Louisville, Allen became friendly with soldiers from the Forty-Fourth Illinois volunteer infantry regiment. The unit was camped near Louisville. Allen disguised himself with the help of Union soldiers, escaping his slave master and going off to war as a civilian nursing aide. In 1863, Allen enlisted in the United States Navy, where he served as a clerk and the captain's steward. On April 4, 1865, ten days before the assassination of President Abraham Lincoln, Allen Allensworth was honorably discharged from the U.S. Navy. He was soon reunited with his mother and his brother William. He gained employment as commissary to the commandant of the Mound City Navy Yard.

In 1867, he pooled his savings with his brother William and opened two restaurants in different parts of St. Louis. Even in the face of widespread discrimination in the business community, the two restaurants prospered, and the brothers were able to sell them for a good price. Allen found work in Louisville, Kentucky, with two different families before he joined the Fifth Street Baptist Church, where he found that the American Missionary Society had organized a Freedman's School in Louisville. He applied for the position of janitor and registered with the school to become one of its first pupils. The school was known as the Ely Normal School. This was the first time that Allen had ever been in a regular school for instruction. He did this while supporting himself and his mother.

Allensworth was soon asked to teach at a small Freedman's School in Christmasville, Kentucky. He credited his naval training and discipline for his success at the school. He was soon asked to head a school at Cave City and later at Hopkinsville. In 1871, Allensworth was ordained a minister of the gospel by members of the Fifth Street Baptist Church in Louisville, Kentucky. Feeling inadequately prepared for the ministry, Allensworth made application to the Baptist Theological Institute at Nashville, Tennessee. He was also preaching at a small church in Franklin, Kentucky.

After his studies, Allensworth became the financial agent of the General Association of the Colored Baptists in Kentucky, while also working as a teacher in Georgetown, Kentucky. The association had as its objective

the formation of a school for religious training of teachers and preachers. This school was called the State University, and Allen Allensworth was one of the founders of the school. The school was an effort put forth by newly freed Black men who wanted to establish a self-supporting institution for the moral and intellectual advancement of the race. Reverend W.J. Simmons became the school's first president, with Reverend Allen Allensworth guaranteeing half of his salary. Reverend Allensworth was called to Louisville, Kentucky, to pastor the Harney Street Baptist Church; he successfully reorganized the church, attracting many new members. Renaming the church Centennial Baptist Church, the energized congregation raised money and built a new church.

Because of his success in Louisville, Reverend Allensworth was called to Bowling Green, Kentucky, to become pastor of the State Street Baptist Church. There were only two objections to him becoming pastor of the church. One was that he was not a "Holy Toner," and the second was that he was unmarried. He married his longtime fiancée, Josephine Leavell (1855–1938), on September 20, 1877, in Trenton, Kentucky, with Reverend James Thomas officiating. The church was very proud of its new first lady, who was an accomplished organist and music teacher. The couple had two children together, Eva and Nella Allensworth. Reverend Allensworth's mother came to live with them for a few months before she died in 1878 at the age of ninety-six.

While in Bowling Green, Reverend Allensworth became interested in politics and attended the Republican National Convention as Kentucky's only Black delegate in Chicago, Illinois. He actively supported the presidential campaign ticket of Garfield and Arthur. He soon became a well-known and respected public lecturer, with frequent invitations from colleges, literary societies and the public at large. Reverend Allensworth's high moral reputation and history of fair dealing brought him to the attention of the Union Baptist Church of Cincinnati, Ohio. The church had been without a pastor for five years and was seeking someone of Reverend Allensworth's caliber to lead the prosperous and well-organized Cincinnati congregation. This opportunity came at a fortunate time for the Allensworth family. Reverend Allensworth's two daughters were growing, and he wanted to afford them the opportunities in education and social development that Cincinnati, Ohio, had to offer. After serving one year as pastor of the church, Reverend Allensworth was requested by unanimous vote of the membership to continue as pastor. Reverend Allensworth organized the building fund, which led to the building of a brand-new house of worship that would hold a larger congregation.

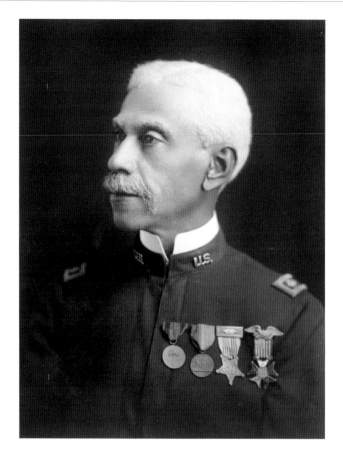

Allen Allensworth, former slave, lieutenant colonel in the United States Army and visionary. *Miriam Matthews Charitable Trust and African American Museum.*

In 1882, the United States military had two cavalry units and two infantry units that were segregated. One of the complaints was that there were not any Black chaplains. A Black soldier approached Reverend Allensworth to discuss the issue. Reverend Allensworth found out that the chaplain of the Twenty-Fourth Infantry was set to retire in four years. Reverend Allensworth made up his mind that he would campaign to be appointed chaplain of the Twenty-Fourth. With the backing of Republican and Democratic officeholders, including Senator Joseph E. Brown of Georgia, Reverend Allen Allensworth was appointed by President Grover Cleveland as chaplain of the Twenty-Fourth Infantry with the rank of captain in April 1886.

He was ordered to join the command at Fort Supply, Indian Territory (Oklahoma). His trip was difficult, as he was refused service at hotels and

eaties even though he was in uniform. When he arrived at Fort Supply, the white soldiers refused to salute the Black officer. According to Allensworth biographer Charles Alexander, Captain Allensworth dealt with this affront in a unique way:

> He announced at the Sunday evening service that on the following Sunday he would preach from the subject: "An Officer Hung for the Want of a Salute." This brought about a large attendance from all the command. He took the case of Haman, who planned the destruction of Mordechai because he did not salute him, and made the point that Mordechai should have saluted Haman regardless of his personal opinion of him; that Haman should have been considerate of the subject and should not have planned to destroy him because he refused to salute him. The Chaplain stated with great emphasis that had he been Haman, he would not have cared to have such a man salute him, that it was just as distressing to have to receive the salute from such a man, as for such a man to be forced to make the salute; and that he would prefer to go out of his way to avoid receiving a salute from such a man, who, having sworn that he would obey the rules and regulations of Army, would thus violate his oath.

The next morning, while he passed by the barracks, the porch was well filled with the men of the Twenty-Fourth Infantry to see what would happen. As he passed down the company street, members of the Fifth Cavalry stood at "attention" and gave the usual salute, and the Twenty-Fourth Infantry rejoiced that its chaplain had secured obedience to duty without putting men in the guardhouse. This policy was followed during his entire service.

Sixty days after his arrival at Fort Supply, Captain Allensworth was joined by his wife and two daughters. As a chaplain, Allensworth provided spiritual comfort to his soldiers. His personal emphasis on education caused him to write a course of study outline and a book titled *Rules Governing Post Schools*, which became the standard army manual regarding the education of enlisted personnel. Captain Allensworth served as an army chaplain for twenty years, including a tour of duty in the Philippines during the Spanish-American War. He retired with the rank of lieutenant colonel, making him the highest-ranking Black officer in the United States Army at that time.

After retiring from the army and a lecture tour in the East and the Midwest, Lieutenant Colonel Allensworth brought his family to Los Angeles, California, in 1906. Colonel Allensworth was troubled by the continuing legacy of disenfranchisement, discrimination, segregation and lynching that

Colonel Allen Allensworth's Los Angeles home. *Miriam Matthews Charitable Trust and African American Museum.*

was prevalent throughout the United States. Even in Los Angeles, California, discrimination against Black people was rampant and entrenched, as vicious as it was casual. Following in the footsteps of Booker T. Washington, he envisioned an agricultural colony where Black people would be free to pursue life, liberty and happiness without having to deal with the casual racism and humiliation that was endemic to the American culture.

In Los Angeles, he soon found kindred spirits who believed in the Booker T. Washington philosophy. Together with William Payne, John W. Palmer, William H. Peck and Harry A. Mitchell, a real estate agent, Colonel Allensworth began to advocate his vision of an agricultural colony where Black people were able to control their destiny. He naturally approached the Black church community to raise funds for the purchase of land and recruitment of settlers. After raising the necessary funds, the problem was that no one would sell to them. Eventually, they were approached by the white-owned Pacific Farming Company, which offered them land in Solito, California, approximately thirty miles north of Bakersfield, California.

The land seemed to be fertile, and Pacific Farming Company agreed to provide the town with an adequate supply of water. The most impressive

fixture for the future town was that it had a railroad station where trains stopped on their way from San Francisco to Los Angeles and from Los Angeles to San Francisco. This was perfect for a community whose primary source of income would be agriculture. In 1908, Colonel Allensworth and his associates formed the California Colony and Home Promoting Association. On August 3, 1908, the organization filed a township site plan with the Tulare County recorder. This was the start of what was to be the town of Allensworth, California. After years of planning and organizing, Colonel Allensworth's vision was becoming reality. The township of Allensworth would be a place where Black people could live and work in dignity and peace. Within the first year, thirty-five families moved to the town. The land in the southern part of the San Joaquin Valley was fertile. Soon there was a United States Post Office, a library, a school and two general stores.

As the community grew, civic organizations such as a theater group, a debate team, a church choir and a chapter of the Camp Fire Girls brought a sense of community to the new town. Colonel Allensworth saw that his town had the potential to become the "Tuskegee of the West." Colonel Allensworth would speak at Black churches throughout California in an effort to raise funds and recruit new residents to Allensworth. On September 14, 1914, Colonel Allensworth was in Monrovia, California, to give one of his lectures to the local Black church in support of Allensworth Township. As he stepped off the streetcar, he was run down by two white boys on a motorcycle. Was it accidental or intentional? It was never proven.

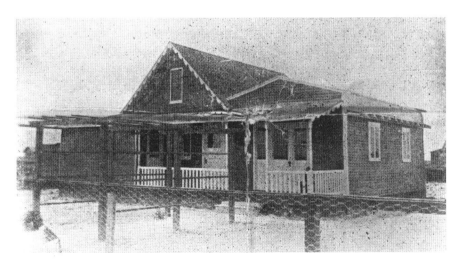

Colonel Allen Allensworth's home in the Black township of Allensworth, California. *Miriam Matthews Charitable Trust and African American Museum.*

Colonel Allensworth's death was the beginning of a downward slide for the Allensworth community. Soon after his death, the Santa Fe railroad that refused to hire any Black staff at the Allensworth station built a line to bypass Allensworth. The Pacific Farming Company began to renege on its contractual obligation to provide adequate water to the township. The groundwater mysteriously became contaminated with arsenic. Without water, the town could not prosper. As most of the original settlers began to leave to find work in other areas, the goal of the few remaining settlers was to preserve what was left of the town called Allensworth. In 1973, the state acquired the property and preserved it as a state park. The Allen Allensworth State Historic Park was dedicated on October 6, 1976, a testament to a man and his dream of freedom and equality.

JOHN AND AMANDA BALLARD

We think of Malibu, California, as a place of sun, surfing and Hollywood celebrities. Movies such as *Beach Blanket Bingo* or the television series *Gidget* come to mind. Very rarely is a thought given to the early inhabitants of Malibu and its surrounding areas.

For thousands of years, the Chumash Indians called the area that we call Malibu home. The Chumash called it *Humaliwo* (or "the surf sounds loudly"). Early Spanish explorer Juan Rodriguez Cabrillo is believed to have visited the area to resupply his ships in October 1542. He reported sophisticated, prosperous villages peopled by intelligent and handsome men, women and children. He marveled at the well-crafted canoes that came out to greet his ships and named the area "Pueblo de las Canoas" ("Town of the Canoes").

With the arrival of the Spanish and the beginning of the mission period, what we know now as Malibu became part of the Spanish land grant known as "Ranchero Topanga Malibu Sequit," granted to José Bartoleme Tapia, a member of Juan Batista De Anza's expedition of 1775 and a Spaniard of African descent.

At the end of the Mexican-American War, the victorious American government, in an effort to circumvent the Treaty of Cahuenga, authorized the United States Land Commission to investigate the legality of the Spanish/Mexican land grants. The Tapia family land grant was challenged and eventually sold to an Irishman, Matthew Keller. Keller was able to clear the title to the land, but he died in 1881; his son, Henry Keller, sold the

property to Frederick Hastings Rindge, whose descendants operate family businesses under the name of the Adamson Companies today.

Above Malibu in the mountains, overlooking the ocean, the owner of 320 acres near what is now Seminole Hot Springs was a man named John Ballard. A former slave from Kentucky, he was a blacksmith, a firewood salesman, a teamster and a landowner. Born into bondage in 1830 in the slave state of Kentucky, he was a free man in 1859 when he arrived in Los Angeles with his wife, Amanda. He soon developed a successful delivery service. Saving his money, he invested in local real estate and became a founding member, along with six others (including Bridget "Biddy" Mason), of the First African Methodist Episcopal Church of Los Angeles, known as FAME.

With the arrival of the railroad and the accompanying land boom in Los Angeles, the beginnings of racial segregation reared its ugly head in the 1880s. Not wanting his family to have to endure the humiliation of segregation, John and Amanda Ballard packed up their family of seven children and moved to a small valley on 160 acres that would later become 320 acres when their daughter Alice purchased the adjoining property on the Santa Monica mountain range overlooking Malibu near present-day Seminole Springs.

John Ballard, a powerfully built man, worked as a blacksmith on the Russell Ranch, a cattle ranch in what is now Westlake Village. He gathered firewood and sold it in Los Angeles. He also raised livestock and had crops on his own land. In his book *Happy Days in Southern California*, Frederick Rindge, the wealthy Malibu landowner, gave an account of a conversation that he had with Andrew Sublett, a local mountain man: "He brought to mind how his old 'colored' neighbor across the range had been maltreated by the settlers on account of his color; how they set fire to his cabin, hoping thus to terrorize him and drive him from the country; how some thought that the real purpose was that some men with white faces and black hearts wanted to jump his claim after they got rid of him. But this was not the material the good old gentleman was constructed of, and as a shame to his tormentors, he put up a sign over the ruins of his cabin which read: 'This was the work of the Devil.'"

The United States Census of 1900 showed that John Ballard was a widower, with a daughter and two grandsons living with him. John Ballard died in 1905. His daughter Alice married and moved to Vernon, California, in about 1910. The mountain that the Ballards had settled on in the 1880s became known as "Nigger Head Mountain" until the name was changed to

Ballard Mountain in 2009. A plaque dedicated to John and Amanda Ballard sits above Tunnel 3 on Kanan-Dume Road, halfway between Agoura Hills and Malibu, California.

REVEREND WILLIAM SEYMOUR

When we think of the Pentecostal movement today, the first thing that comes to most people's minds are the televangelists—names like Kenneth Copeland, Benny Hinn, Jimmy Swaggart and Rex Humbard, to name just a few. A generation before the televangelists, well-known radio preachers and tent revivalists with names like Aimee Semple McPherson, Oral Roberts, Kathryn Kuhlman and Jack Coe were staunch representatives of the Pentecostal movement that was sweeping the globe. But where and how did the Pentecostal movement start?

Just outside the town of Centerville in St. Mary's Parish, Louisiana, there is a sugar plantation that was owned by Adllard Carlin. On May 2, 1870, William J. Seymour was born there. Both of his parents, Simon and Phyllis Seymour, had been slaves and were now sharecroppers living under the racial terror and oppression that was common in the post–Civil War South, with Louisiana having one of the highest rates of racial lynching in the nation. Simon Seymour had been a soldier with the United States Colored Troops, the segregated unit of the United States Army. During his tour of duty, he contracted what may have been malaria in the southern swamps and was hospitalized in New Orleans. After the war, he settled down in Centerville and married Phyllis Salabar, a former slave on the Carlin plantation.

William Joseph Seymour grew up during a time of intense racial violence in the United States. In the 1890s, when southern legislatures were enacting the oppressive "black codes," the precursor to "Jim Crow" segregation laws, William left the South and traveled north to Memphis, to St. Louis and, in 1895, to Indianapolis, where he joined the Simpson Chapel Methodist Episcopal Church and became a born-again Christian. In 1901, William attended a Bible school in Cincinnati, where he developed his theology and his belief in a non–racially segregated church. It was in Cincinnati that William Seymour contracted smallpox and went blind in his left eye. After his recovery, he was ordained by the Evening Light Saints, a group led by Daniel S. Warner.

After a brief stint in Jackson, Mississippi, where he worked with Charles Price Jones, the founder of the Church of Christ (Holiness), Reverend William J. Seymour traveled to Houston, Texas, in search of family members. In 1903, while in Houston, he joined a Holiness church led by Lucy Farrow, a charismatic Black woman and a niece of the famed abolitionist Frederick Douglass. It was Lucy Farrow who introduced Reverend Seymour to Charles Fox Parham, a well-known white evangelist and faith healer who had opened a Bible training school in Houston. Reverend Seymour asked to attend the Bible school and was accepted on the condition that he not sit in the classroom with the whites but rather take his lesson outside an open door or window. Despite this humiliation, Reverend Seymour agreed, and for a short time, a matter of a few weeks, he put up with Parham's racist humiliation in order to learn about the gifts of the Holy Spirit, including speaking in tongues.

While in Houston, Reverend Seymour met Neely Terry, a woman from Los Angeles, California, who gave him a description of a growing Black religious community and a church that was in need of a preacher. Believing he was called by God, Reverend Seymour arrived in Los Angeles on February 22, 1906. He began preaching in a Holiness church established by Julia M. Hutchins. He preached about the gifts of the Holy Spirit, including speaking in tongues, and against racial segregation in the church. Julia Hutchins disagreed with Reverend Seymour on the issue of speaking in tongues and expelled Reverend Seymour from her church. Reverend Seymour soon began to hold Bible study at the home of Mr. Edward Lee, but his prayer group became too large and had to move to the home of Mr. and Mrs. Richard Asberry at 214 North Bonnie Brae Avenue in Los Angeles.

It was at the home of Mr. and Mrs. Asberry that Reverend Seymour received the gift of the Holy Spirit and began speaking in tongues. On April 9, 1906, while preaching, several members of his congregation began spontaneously speaking in tongues. This went on for three nights of intense prayer and worship.

As the word spread about the movement of the Holy Spirit taking place at the house on North Bonnie Brae, the excited crowd soon overwhelmed the Asberry home, causing the front porch to collapse under the weight of the parishioners. The growing congregation found a new home in a building that had been used by the African Methodist Episcopal Church at 312 Azusa Street in a run-down part of a Black business district. This address gave the religious movement its name, the "Azusa Street Revival," and gave Reverend Seymour a place to live in the upstairs apartment. Reverend Seymour

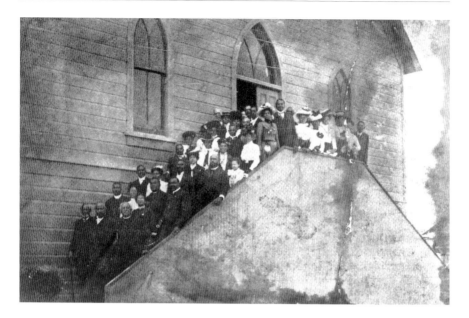

Originally the site of the First African Methodist Episcopal Church (FAME), this became the site for Reverend Seymour's Azusa Street miracle that began the modern-day evangelical movement in April 1906. *Miriam Matthews Collection, UCLA.*

began to preach about the gifts of the Holy Spirit and the importance of a racially integrated church. His congregation included whites, Asians and Hispanics in his majority Black congregation. The congregation grew with the outpouring of the Holy Spirit, and Reverend Seymour was forced to conduct three services a day beginning at 10:00 a.m., noon and at 7:00 p.m. to accommodate his growing congregation. The church kept up this schedule for more than three years. In his church services, demons were removed, the sick were healed and many were called to Christ. The most controversial aspect of the church, besides being interracial, was the moving of the Holy Ghost that caused parishioners to speak in tongues.

The "Azusa" revival soon caught the attention of the newspapers. On April 17, 1906, a reporter from the *Los Angeles Times* wrote an article mocking the Azusa Street Revival and its "colored one eyed preacher" with his "new sect of fanatics." The article was printed the next day, April 18, 1906, the date of the devastating San Francisco earthquake and fire. Many of the faithful saw this as a sign that the end days were coming soon. Thousands crowded into and around the sanctuary, overflowing into the dirt streets. Black and white, rich and poor, gathered to hear the word as delivered by Reverend William J. Seymour. With the help of Clara Lum, a white member

of the church staff, the ministry soon produced a newspaper of its own, the *Apostolic Faith*. Reverend Seymour's sermons were reprinted in the church newspaper along with the news of meetings and other church business. The circulation of the newspaper was said to have surpassed fifty thousand, and it spread the message of the Pentecostal movement across the globe.

The church was visited by many religious leaders, who took the teachings of Reverend Seymour back to their own churches and around the world. Others, such as Emma Cotton, who would found and pastor her own church, the Azusa Temple in Los Angeles (known today as Crouch Memorial Church), were inspired to become evangelists and pastors in their own right under the teaching of Reverend Seymour. Other churches invited Reverend Seymour to speak, and he traveled extensively, sharing his message of the power of the Holy Spirit. The evangelist John G. Lake visited Azusa Street and said of Reverend Seymour, "He had the funniest vocabulary. But I want to tell you, there were doctors, lawyers and professors, listening to the marvelous things coming from his lips. It was not what he said in words, it was what he said from his spirit to my heart that showed me he had more of God in his life than any man I had ever met up to that time. It was God in him that attracted the people."

The success of the Azusa revival movement inflamed jealousy and bred critics of Reverend Seymour. Charles F. Parham, the famous white evangelist whose Bible school Reverend Seymour had attended, journeyed to Los Angeles in October 1906 to experience the Azusa revival for himself and to bring Reverend Seymour into his fold. Upon arriving in Los Angeles, Parham was appalled by the emotional worship and disgusted by the mingling of white and Black parishioners. He was particularly offended when he saw Black men laying hands on white women; it seems that he didn't have a problem with white men laying hands on Black women. He registered his displeasure with Reverend Seymour, and later, in his contempt, he accused him of serving Satan. Parham set up a rival congregation nearby, taking some of Reverend Seymour's white parishioners with him.

In 1908, a second blow to Reverend Seymour's ministry would take place following his marriage to longtime church worker Jennie Evans Moore. They were married on May 13, 1908, and took up residence in the upstairs apartment above the church. In what some have described as a fit of jealousy and rage, Clara Lum, who many believed was secretly in love with Reverend Seymour, left the church for a mission established by a white missionary named Florence Crawford (founder of the Apostolic Faith Church), who had been active in the Azusa church under Reverend Seymour and had

established a church mission in Portland, Oregon. When Lum left, she stole the entire fifty thousand national and international names and addresses of supporters and subscribers to the church newspaper and began publishing the newspaper and soliciting donations from Portland, Oregon, with no mention of Reverend Seymour or his ministry, effectively crippling the Azusa ministry.

The next major blow to the ministry came in 1911. Reverend Seymour was in great demand as a speaker, and as he traveled, his wife would invite guest speakers to preach while he was away. On one such occasion, she invited William H. Durham, a well-known Chicago evangelist and faith healer, as a guest preacher. Durham had attended services at the Azusa Street mission in 1907 and had received the baptism of the Holy Spirit there. But in an age of segregation and casual racism, Durham could not accept Reverend Seymour's leadership. With Reverend Seymour on the road, Durham sought to take over the congregation in his absence. Upon his return, Reverend Seymour expelled Durham from his congregation. Durham left, taking many of the remaining white members of the congregation with him as he started a rival church just a few blocks away. Within a year, Durham had died of pneumonia, but his defection was the last crippling blow to Reverend Seymour's ministry. Over the next few years, the Pentecostal movement that came out of the experience of the Azusa Street Revival began to split along racial lines. As the white congregations that came out of the Azusa movement grew, Reverend Seymour found himself marginalized and, eventually, all but forgotten. On September 28, 1922, Reverend William J. Seymour suffered two heart attacks and died in the arms of his wife. He is buried at Evergreen Cemetery in Los Angeles, California. His wife, Jennie Seymour, continued her husband's work after his death. She passed away on July 2, 1936, and was buried next to her husband. Reverend William J. Seymour's legacy is the worldwide Pentecostal movement, with over seven hundred denominations and more than 279 million followers.

TO BE EQUAL

Nobody can give you freedom. Nobody can give you equality or justice or anything. If you're a man you take it.

—Malcolm X

H. CLAUDE HUDSON

Dr. Henry Claude Hudson, more popularly known as H. Claude Hudson, was born on April 19, 1886, in Marksville, Louisiana. Marksville is in Avoyelles Parish, the same parish where the author of *Twelve Years a Slave*, Solomon Northrup, was kidnapped and held illegally as a slave. The son of former slaves, Claude was born into a sharecropping family.

While working as a bricklayer, Claude enrolled in the dental school at Howard University in Washington, D.C. While at Howard University, Claude became politically active. H. Claude Hudson and a group of activists under the leadership of Dr. W.E.B. Du Bois tried to meet in a hotel in Niagara Falls in 1905 but were unable to rent a room on the American side of the border because of their race. So, they rented a hotel room on the Canadian side. Their group became known as the "Niagara Movement." "But no one knew what the devil the 'Niagara Movement' meant," Dr. Hudson would say later. "So the name was changed to the National Association for the Advancement of Colored People in 1910."

After graduating from Howard University dental school, Dr. Hudson returned to Louisiana to practice dentistry and continue his work with the NAACP in Shreveport. While working as the president of the NAACP there, death threats and intimidation from the Ku Klux Klan and its police and political allies made the situation, as Dr. Hudson would later describe it, "tantamount to signing a death warrant." In 1923, Dr. Hudson and his family moved to Los Angeles. Dr. Hudson would not return to the South for forty years, when he would march with Dr. Martin Luther King Jr.

Dr. H. Claude Hudson was a member of the Niagara movement and president of the Los Angeles NAACP. He was chairman of the board of the Black-owned Broadway Federal Bank from 1949 to 1972. He was affectionately known as "Mr. NAACP."

In 1924, Dr. Hudson was elected president of the NAACP chapter in Los Angeles. He became president of the organization at a time when the Los Angeles branch of the NAACP was split between two factions. Using his organizing skills, he was able to heal the rift in the local chapter, and in 1925, he successfully challenged the discriminatory Jim Crow–like swimming laws at local beaches. In 1928, the Los Angeles branch of the NAACP successfully hosted the nineteenth annual NAACP Convention. Dr. Hudson would lead the Los Angeles chapter of the NAACP for ten years. In 1927, Dr. Hudson enrolled in Loyola Law School in order to augment his work with the NAACP. Dr. Hudson became the first Black man to graduate from Loyola Law School. Dr. Hudson worked with iconic figures such as Loren Miller, the crusading civil rights attorney and journalist who challenged the enforcement of "racial covenants" that were used to facilitate housing discrimination all the way to the Supreme Court. He mentored the legendary Black politician Augustus F. Hawkins, who described him as "like a second father." In 1934, when Leon Washington, publisher of the *Los Angeles Sentinel* newspaper, was arrested during his boycott of major retail stores that operated in the Black community but refused to hire Black people, it was Dr. Hudson who bailed him out of jail, according to Ruth Washington, Leon's wife. "Up until the time he died, Leon was always grateful to Dr. Hudson."

In 1947, Dr. Hudson became one of the founders of Broadway Federal Savings and Loan Association. During his tenure as its president and board chairman, he grew the institution's assets from $3 million to $66 million. The savings and loan's mission was to provide financing for homeowners

and businesses in the Black community that were denied financing by larger white institutions. Many Black businesses today owe their start to financing made available by Broadway Federal Savings and Loan Association.

In the early 1960s, Dr. Hudson and his family moved to the View Park area of Los Angeles. Almost overnight, "For Sale" signs sprouted like wildflowers, and Dr. Hudson's front picture window was repeatedly smashed by rocks thrown by disgruntled racist neighbors. Even as he and his family were attacked by racists, he was able to lend a helping hand to the widow of civil rights activist Medgar Evers, who was assassinated in Mississippi in 1963. Mrs. Evers said she will never forget how Dr. Hudson looked after her and her children when her husband was assassinated. "He was the one who moved us from Mississippi to California," remembered Mrs. Evers.

In the aftermath of the Watts rebellion, a commission was formed to try to understand the motivations of the rebellion. One of the glaring problems was lack of medical care. Dr. Hudson worked with supervisor Kenneth Hahn to help found the Martin Luther King Jr. County Hospital in the Watts/Willowbrook area of Los Angeles. Supervisor Hahn called Dr. Hudson "one of the key doctors responsible for the creation of the Martin Luther King hospital."

Dr. Hudson received the City of Los Angeles's highest honor, the Distinguished Service Medal, in 1976. In 1979, the former John Wesley Hospital was renamed the H. Claude Hudson Comprehensive Health Center. The Los Angeles Board of Supervisors named an auditorium in the Martin Luther King Jr. County Hospital after Dr. Hudson.

In 2006, Paul C. Hudson—attorney, Los Angeles city commissioner, former president of the Los Angeles branch of the NAACP and H. Claude Hudson's grandson—took over as chairman of Broadway Federal Bank, with assets exceeding $225 million and more than thirteen thousand accounts. The bank is still serving the community well into the third generation, a living legacy to Dr. H. Claude Hudson. He passed away in his sleep on January 26, 1989, at the age of 102.

Betty Hill

Betty Hill started life sometime around 1882, born Rebecca Jane Perkins. It was said that her grandfather purchased his wife out of slavery. What is known is that her father built the first school open to Black people in Davidson County, Tennessee. Stressing education, she first attended her father's school

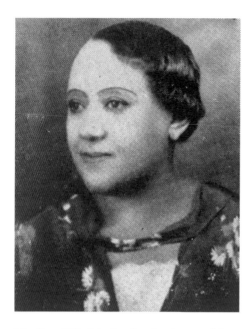

Mrs. Betty Hill of the Los Angeles chapter of the NAACP. *Miriam Matthews Collection, UCLA.*

and later attended public school in Nashville, Tennessee. As a young woman, Betty studied religion at Roger Williams University, an all-Black institution that was founded in 1866.

In 1898, Betty married Abraham Houston Hill, a Nashville native and a sergeant in Company B of the Twenty-Fourth United States Army Infantry Regiment known as the "Buffalo Soldiers." Sergeant Hill took part in the Spanish-American War and was again shipped out to the Philippines in 1902 to participate in the Philippine-American War, with his wife traveling with him. After the retirement of their good friend Lieutenant Colonel Allen Allensworth, who was the chaplain to the Twenty-Fourth Infantry, Sergeant Hill's wife, Betty, took over chaplain duties until a replacement could be had. Sergeant Abraham Hill retired from the army in 1913, moving with his wife to Los Angeles, California. The Hills bought a home at 1655 West Thirty-Seventh Place in Los Angeles. The Hills also participated with Colonel Allensworth in the building of the Black township in Tulare County called Allensworth. Most of the original inhabitants of Allensworth were retired members of the Twenty-Fourth Infantry who answered the call of Booker T. Washington's philosophy as it was envisioned by Colonel Allensworth and others on the West Coast.

Upon moving to Los Angeles, Betty Hill quickly became involved in the Los Angeles Black community. She taught Sunday school and was a founding member and later vice-president of the Los Angeles chapter of the National Association for the Advancement of Colored People (NAACP). Betty was also a founding member of the Los Angeles chapter of the Urban League. Betty was an admirer of both Booker T. Washington and W.E.B. Du Bois and took the best of each philosophy to develop her own brand of political activism. She was instrumental in forming the Westside Homeowners Association, which worked for self-protection and to fight discrimination and bigotry. Betty would also use the association and the NAACP to win a stunning victory in her quest for equal rights known as the "swimming pool case."

The Los Angeles Playground Commission had developed a policy that allowed Black residents to use the new city swimming pool in Exposition Park only on "colored day," which was usually just before the pool was cleaned or drained. With her characteristic persistence, Betty was able to bring the issue to court in 1931, where Judge Walter S. Gates ruled against the discriminatory policy. When the city council threatened to appeal Judge Gates's decision, Betty lobbied each city council member individually until time for the appeal ran out. Betty also founded the Women's Republican Study Club, which she used to promote civil rights and racial justice. After the Black community began to move toward the Democratic Party with the election of Franklin Delano Roosevelt, she soon dropped the name "Republican" in the face of the new reality.

During World War II, Betty was involved in the Double V campaign to end fascism overseas and racial discrimination in the military and at home. On a trip to

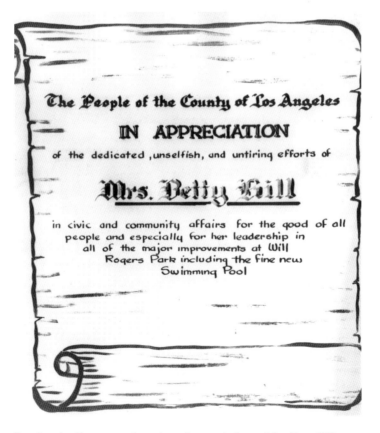

Los Angeles County proclamation of appreciation to Mrs. Betty Hill.
Miriam Matthews Collection, UCLA.

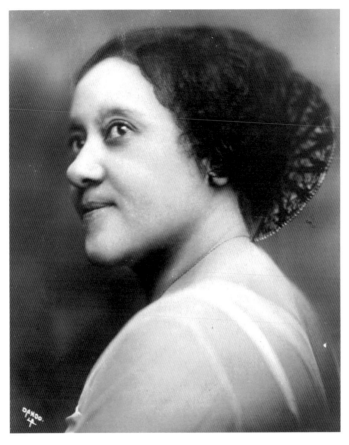

A portrait of Los Angeles civil rights icon and "race woman" Mrs. Betty Hill. *Miriam Matthews Collection, UCLA.*

Washington, D.C., in 1945, she was appalled by the racial segregation that she experienced in the nation's capital. Working with Republican congressman Gordon McDonough, she wrote a bill to end Jim Crow discrimination in the nation's capital. In 1946, the bill was submitted to Congress but never made it out of committee and soon died. Persistent as ever, Betty, with support from the Women's Political Study Club, went to Washington in person to present President Harry S Truman with a resolution condemning Jim Crow racism in the capital of the United States of America.

Through her activism and organization, Betty Hill is responsible for the challenge to and elimination of Jim Crow practices in institutions throughout the Los Angeles area. She also hosted fundraisers to further the education of deserving students and was the first Black female delegate west

of the Mississippi to the Republican National Convention, in Philadelphia in 1940. She made history as the first Black woman to run a major political campaign. In 1932, Senator Samuel M. Shortridge asked her to manage his campaign for reelection; unfortunately, he lost in the primary.

Betty Hill passed away on May 12, 1960. Because of her leadership and activism, along with that of many others, Jim Crow segregation was challenged and legally defeated in California. In her honor, Los Angeles city councilman Robert Farrell, himself a "Freedom Rider" and civil rights activist, renamed the Denker Building at the Denker Senior Citizens Center the Betty Hill Building on May 16, 1980. On June 6, 1980, the Denker Senior Citizens Center itself was renamed the Betty Hill Senior Citizens Center, located at 3570 South Denker Avenue, Los Angeles. It is less than a mile from her home, which was designated Los Angeles cultural monument no. 791.

CHARLOTTA BASS

In 1879, a former slave by the name of John J. Neimore founded a newspaper in Los Angeles, California. The newspaper's mission was to serve the Black community by providing information that could lead to employment and housing, entertainment and the news of the day in a city that practiced subtle as well as outrageous forms of segregation. The newspaper served as a guide to new Black migrants from the Deep South as they navigated the sometimes confusing and contradictory system of segregation that was practiced in Southern California.

The *Owl* would soon become an institution in Los Angeles's Black community. I am sure that when John J. Neimore founded his newspaper in 1879, he had no idea of the fruit that it would bear over the next eighty-five years of its existence.

In 1910, Charlotta Spears arrived in Los Angeles, California, from Providence, Rhode Island. Charlotta was born in Sumter, South Carolina, on February 14, 1874. Her parents were Hiram and Kate Spears, and she had ten siblings. She left South Carolina at the age of twenty and shared housing with her brother in Providence, where she worked for a local newspaper, the *Providence Watchman*. In 1910, she moved to Los Angeles and found a job working for John J. Neimore's newspaper the *Owl*. After only two years, Charlotta obviously impressed Mr. Neimore with her work ethic and vision. According to her

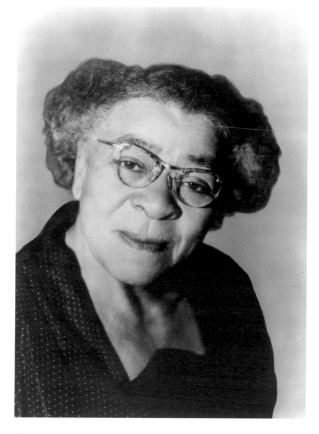

Crusading newspaperwoman, civil rights icon, congressional and vice presidential candidate Mrs. Charlotta Bass. *Miriam Matthews Collection, UCLA.*

autobiography, in 1912 a very ill John J. Neimore called Charlotta to his bedside and made her promise to keep the newspaper alive.

After Mr. Neimore's death, Charlotta took over the newspaper and renamed it the *California Eagle.* She hired Joseph Bass, an experienced newspaper publisher and community organizer who had moved to Los Angeles from Helena, Montana. Mr. Bass was born in Jefferson City, Missouri, in 1863. After a stint teaching school, Joseph Bass took over ownership of the *Topeka Call* in 1896 and sold the newspaper in 1898. It later became known as the *Topeka Plain Dealer.* He remained with the newspaper until 1905, when he moved to Helena, Montana, to establish his own newspaper, the *Montana Plain Dealer,* servicing the Black community there. By 1912, he was in Los Angeles, California, working as a writer for the *California Eagle.* By 1913,

Joseph Bass had become the editor of the *Eagle*, and in 1914, he married Charlotta Spears, the owner of the newspaper. Joseph and Charlotta Bass shared the same vision for their newspaper. They both wanted it to be an advocate against racism, discrimination and injustice.

February 1915 saw the release of D.W. Griffith's film *The Birth of a Nation*. The epic silent film based on the book *The Clansman* by Thomas Dixon Jr. tells the tale of two families during the post–Civil War Reconstruction era. One family, the Stonemans, were pro-Union, and the other family, the Camerons, were supporters of the Confederacy. The movie painted the Ku Klux Klan as noble saviors of a defeated South forced to endure the excesses of a former slave population backed by a vengeful Northern government. The movie painted Black elected officials in the reconstructed Southern governments as incompetent, corrupt and ignorant, with an insatiable appetite for Southern white women and chicken. The film was a great box office success and was used as a recruitment tool to reenergize and strengthen the Ku Klux Klan.

The *California Eagle* took exception to the movie's portrayal of Black people. The *Eagle*, under the direction of Charlotta Bass, began a campaign along with the NAACP to ban the film but met with limited success outside the Black community. Led by Charlotta Bass's scathing editorials against the film's glorification of white supremacy and the Ku Klux Klan, other Black newspapers across the country joined with her to protest the film.

In 1917, the *California Eagle* and Bass denounced the unjust prosecution and execution of Black soldiers involved in the 1917 "race riot" in Houston, Texas. The newspaper supported Black railroad union activist A. Philip Randolph as he fought discrimination against Black railroad workers. Bass spoke out against the railroading of the Scottsboro boys by an all-white southern jury. In 1919, Bass attended the Pan African Congress organized by W.E.B. Du Bois in Paris, France. In the 1920s, she became active in Marcus Garvey's Universal Negro Improvement Association (UNIA), as well as becoming a leading member of the local chapter of the National Association for the Advancement of Colored People. Mrs. Bass was a founder of the Industrial Business Council, which fought against discrimination in employment and sought to develop Black entrepreneurs. She organized the Home Protective Association, which sought to protect Black homeowners against vigilante violence and challenge the practice of racial housing covenants.

After her husband's death in 1934, Charlotta Bass managed the *California Eagle*, and it continued to be an advocate for the Black community. After leading the community in a confrontation with Los Angeles mayor Fletcher Bowron over the issue of racial discrimination, Mrs. Bass decided to run

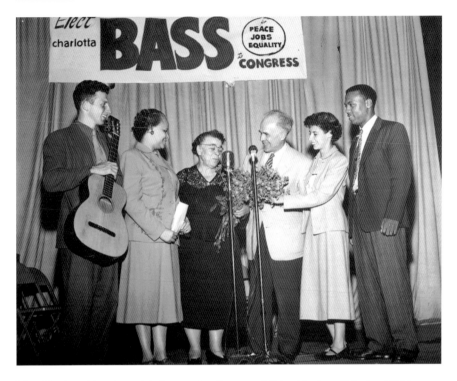

Mrs. Charlotta Bass (center) in her run for Congress. *Miriam Matthews Collection, UCLA.*

for a seat on the Los Angeles City Council in 1945. Even though she did not win the election, she was able to articulate issues that were important to the Black community. By 1950, she had left the Republican Party for the Progressive Party because of its stance on civil rights. That same year, she ran a campaign for Congress on the Progressive ticket, articulating social and economic positions that were important to the Black community. In 1952, Charlotta Bass became the Progressive Party's candidate for the office of United States vice president. This made her the first Black woman to run for national office. A year earlier, in 1951, Charlotta Bass had sold the *California Eagle* to her former city editor, attorney Loren Miller.

In 1966, Charlotta Bass suffered a stroke. On April 12, 1969, she died of a cerebral hemorrhage in Los Angeles, California. She left a rich legacy and provided a platform so that others could continue the work that started with J.J. Neimore in 1879.

Judge Loren Miller

Judge Loren Miller was born in the small town of Pender, Nebraska, just outside the city of Omaha on January 20, 1903. He was the second of seven children born to John Bird Miller, who was born into slavery, and Nora Magdalena Herbaugh Miller, a white woman of German and Irish descent born in Stoutland, Missouri. At an early age, it became evident that Loren had an insatiable thirst for knowledge. He learned to read at a very young age, was an enthusiastic reader all of his life and dreamed of a life as a writer. As he grew older, he read in order to escape the grinding day-to-day poverty and discrimination that he would one day fight against. According to Dr. Amina Hassan's book *Loren Miller: Civil Rights Attorney and Journalist*, Loren's father helped to cultivate his interest in the law. "From time to time, John Miller took his son along with him to the Thurston County Courthouse, an impressive, Victorian-style brick building on Fifth Street, where he worked as a janitor." There, to his father's delight, Loren developed an interest in the law.

Loren Miller graduated from high school in Highland, Kansas, with honors on May 14, 1920, and was ready to attend the University of Kansas. Loren's whole family pitched in to help provide for his education, according to Dr. Amina Hassan. Loren's younger brother Cecil quit high school in order to work. "Cecil said it is better for Loren to go to college than for me to go to High School," wrote his mother.

In the fall of 1920, Loren Miller was a freshman on the campus of the University of Kansas, where he buried himself in his studies in an effort to ignore the humiliations of his Jim Crow environment. During his time at the University of Kansas, the Midwest was aflame with lynch

Civil rights lawyer, crusading journalist and judge Loren Miller. *Miriam Matthews Collection, UCLA.*

mobs and massacres of Black populations in cities such as Elaine, Arkansas; the Greenwood section of Tulsa, Oklahoma; Chicago, Illinois; and Omaha Nebraska. These events are known to historians as the Bloody Summer of 1919–20, but these attacks were ongoing and were, for the most part, ignored by the federal and local government, leaving Black folks to fend for themselves as best they could in the face of unchecked racial violence. These events had a profound effect on Loren Miller, but not as profound as the death of his father on November 18, 1920; he had taken ill three months earlier. He was only fifty-nine years old.

After attending the University of Kansas and, later, Howard University, Loren Miller graduated from Washburn University in Topeka, Kansas, with a law degree. He passed the bar in 1928, the same year he graduated, and began practicing law in Topeka, Kansas, putting his first love (writing) on the back burner. But fate would soon intervene and put Loren on a new direction. On September 10, 1929, Loren's sister Ruby Lily Homes died at twenty-three years old, leaving behind three small children in Los Angeles, California. At the time of his sister's death, his immediate family was living in Los Angeles.

Loren Miller arrived in Los Angeles, California, in September 1929, a month before the most devastating financial crisis of the twentieth century and the beginning of the Great Depression. This financial upheaval and the racial inequities that it highlighted began to shape Loren's political point of view. With the help of his friend Langston Hughes, he began to question the capitalist system and started writing on the subject in local Black newspapers. His fiery opinion pieces and local reporting brought him attention and admiration in Los Angeles's Black community. Loren contacted his cousin Leon Washington Jr., who was in Kansas City making a living selling men's clothing. Leon was known as a very good salesman. Loren believed that with his ability to write and with Leon's ability to sell, they would make a great newspaper team. Eventually, Loren and Leon found themselves working at the *California Eagle* with the crusading husband-and-wife team of Charlotta and Joseph Bass.

In 1931, the nation was riveted by the case of the "Scottsboro boys." Traveling as railway hobos, many young people would ride the rails from town to town looking for work. A group of Black teenagers got into a fight with a group of white teenagers on a crowded train. The white teenagers told authorities that they had been attacked and driven off the train by the Black teenagers and that the nine Black teenagers had raped two white women who were also on the train. The Black teenagers were arrested and

taken to Scottsboro, Alabama, for trial, where a lynch mob demanded that they be turned over. The local sheriff called in the National Guard to protect his prisoners and moved them to Gladstone, Alabama, to await trial. Tried by an all-white jury and a judge obviously biased toward the prosecution, all nine of the teenagers were found guilty in a matter of hours. Eight were given the death penalty; the youngest one, who was twelve years old, was given life imprisonment. Loren Miller, along with many in the Black community, were outraged. Loren devoted many of his columns in the *California Eagle* to the cause of the Scottsboro boys. He became part of an international movement to demand justice for the boys.

In 1932, Miller informed his readers that he would be leaving for the Soviet Union. Loren was part of a group that had received an invitation from the Meschrabpom film company in Moscow to make a movie about Black Americans. To make it there, Loren drove across the country with his friend Langston Hughes on a grand adventure. As they crossed the United States in 1932, they experienced the humiliation of Jim Crow at nearly every turn. The danger faced by two young Black men driving across the country was not lost on them as they passed through Ohio and were informed that a Black man had been lynched in a nearby town. Loren and Langston stopped in Cleveland, Ohio, to visit Loren's mother and to leave her money to help with her expenses. By the time Loren and Langston got to New York, they were running late to board the SS *Europa*, one of the newest and fastest steamers that would land Loren and his group in Bremerhaven, Germany, before reaching Russia. Despite some disappointments and contradictions, Loren found that his trip to Russia expanded his view of the world and his role in it. His dispatches from Russia were widely read in the Black press. He found that traveling had matured him; he solidified his friendship with Langston Hughes and other influential activists who had traveled with their group. At twenty-nine years old, for the first time in his life he had felt unencumbered by the humiliations of Jim Crow racial discrimination. For the first time in his life, he felt like a free human being. He considered his trip to Russia to be as much of a turning point in his life as going to college had been.

Upon his return to Los Angeles, Loren Miller resumed his duties at the *California Eagle* as city editor. On February 21, 1933, he married Juanita Ellsworth, a natural beauty who held a bachelor's degree in social work from the University of Southern California and a teaching credential from the University of California–Los Angeles. Unfortunately, that same year, Loren's older brother Cloyd passed away after a short illness.

Soon after his marriage to Juanita, Loren Miller left his job as city editor at the *California Eagle*. Together with his cousin Leon Washington, they started a throwaway newspaper called *Town Talk*. This paper was the forerunner of what was to become the *Los Angeles Sentinel*, one of the most successful Black newspapers west of the Mississippi. The *Sentinel*, like the *Eagle*, would become a platform from which to articulate the concerns and the struggles of the Black community. During the Depression, jobs were very hard to find, especially if you were Black. If you were lucky enough to find a job, it was usually at the lowest-paying positions at the same time many Federal Relief Agency administrators were accused of practicing wholesale discrimination against Black people. It was in this atmosphere in January 1934 that the publisher of the *Los Angeles Sentinel* newspaper, Leon Washington, parked his car in front of Zerg's furniture store and produced a large sign that read, "Don't spend your money where you can't work." This began a campaign challenging businesses in the Black community that refused to hire Black employees. This led to Leon Washington's immediate arrest, which drew hundreds of demonstrators to take up his cause and eventually led to the employment of thousands of Black community members who had been barred from jobs in their own community.

At the urging of his wife, Loren Miller studied for the California State Bar exam. On June 7, 1934, Loren was granted the right to practice law. True to himself, he took up local discrimination cases, as well as probate and divorce cases. Because of his willingness and skill in defending victims of police brutality and discriminatory public accommodation policies, his reputation began to grow. Many of his successful cases were highlighted in the *California Eagle* and the *Los Angeles Sentinel* newspapers, which earned him additional clients and initiated the beginning of a successful law career. It was said that Loren Miller was so dynamic in the courtroom that other lawyers would reschedule their cases just to hear him.

By the 1940s, the demand for housing in the Black community was becoming critical, and the demand to stop discriminatory practices in housing became a battle cry. "Restricted housing covenants" were used to discriminate against potential Black homeowners. In the court case *Fairchild v. Raines* (1944), Loren Miller won the case for a Black Pasadena family who had bought a nonrestrictive lot but were sued by their white neighbors anyway. In 1945, Loren won what was known as the "Sugar Hill case." Black movie stars Hattie McDaniel, Ethel Waters and others were harassed and sued by their white neighbors for moving into the West Adams district known as "Sugar Hill." By 1947, Loren Miller had become the go-to man when it came to fighting discrimination in housing. He was openly critical of the Federal Housing Authority (FHA) and its

institutional racism that legitimized discrimination against Black people. In 1948, Loren Miller and his partner, Thurgood Marshall, the future Supreme Court justice, argued before the Supreme Court the landmark case of *Shelley v. Kramer* that ended the legal enforcement of racial housing covenants. Loren Miller also worked to fight against discriminatory hiring practices in the Los Angeles Fire Department and Police Department. His actions, along with those of other activists such as Arnett Hartsfield, were instrumental in getting rid of the racist Los Angeles fire chief, who had blocked the integration of the fire department.

In 1951, Loren Miller, who began writing for the *California Eagle* when he first came to California and later served as that newspaper's city editor, bought the newspaper from its publisher,

Judge Loren Miller in his judicial robes. *Miriam Matthews Collection, UCLA.*

Charlotta Bass. Loren was able to realize his dream of being a writer and fusing that dream with his work as a noted civil liberties lawyer. Under Loren's leadership, the *Eagle* continued to be a voice against "Jim Crow" segregation, police brutality and discrimination. John James Neimore, the founder of the newspaper, would've been proud. In 1964, California governor Pat Brown appointed Loren Miller to the Municipal Court, where he served until his death on July 14, 1967. The prestigious Loren Miller Legal Services Award is given to the lawyer who has demonstrated a commitment to extending legal services to the poor. The Loren Miller Bar Association, founded in 1968 in Seattle, Washington, is a civil rights organization that confronts institutionalized racism affecting the Black community. In 2003, Judge Robin Miller Sloan was appointed to the Superior Court of Los Angeles County. She is the daughter of the late Judge Loren Miller Jr., the son of the iconic civil rights hero Judge Loren Miller.

PAUL REVERE WILLIAMS

If you were to pick up a travel brochure of sunny Los Angeles, California, "playground of the rich and famous," your brochure would likely feature iconic buildings that represent the California experience. You would see the Theme Building at Los Angeles International Airport as you arrive. You might stay at the Beverly Hills Hotel or the Beverly Wilshire Hotel. You may decide to shop in Beverly Hills at Saks Fifth Avenue or transact business at the Golden State Mutual Life Insurance building or at the Los Angeles County Courthouse. On Sunday, you may want to pray at historic Second Baptist Church or with the oldest Black congregation in Los Angeles at First AME Church. All are Los Angeles icons. As a tourist, you may want to buy a map to the homes of the Hollywood stars. You may look for the homes of past Hollywood royalty like Tyrone Power and Lon Chaney. You may want to see the former home of Lucille Ball and Desi Arnaz or the Trousdale Estates home of Frank Sinatra. You may find yourself enjoying the symmetry, style and functionality of the design of these buildings and homes and wonder: who was the architect who designed these aesthetically pleasing buildings and homes? Unfortunately, very few people know of the legendary Black architect who designed and, in some cases, redesigned many of the buildings and institutions that have come to define Los Angeles and the Southern California lifestyle.

Born in Los Angeles, California, on February 18, 1894, in his parents' home at 842 Santee Street, Paul Revere Williams was the second child of Chester and Lila Williams, who had recently moved to Los Angeles from "Jim Crow" Memphis, Tennessee, with Paul's older brother, Chester Jr. By the time young Paul was five years old, both of his parents had died, and he and his older brother were separated and placed in foster homes. Paul's foster parents, Charles and Emily Clarkson, believed that he should be educated and sent him to Sentous Street Grammar School (named for brothers Jean and Louis Sentous, who owned a cattle ranch in the area), where he found himself culturally isolated as the only Black child in his class. Paul Williams graduated from Polytechnic High School with the class of 1912 and began to pursue an education in architecture. By 1916, he was studying architecture at the University of Southern California while working as an architectural apprentice.

In June 1917, Paul Revere Williams married Della Mae Givens. Paul was an architectural draftsman working for a successful design practice. In the next few years, he won several architectural competitions and began to build a

Legendary architect Paul R. Williams. *Miriam Matthews Collection, UCLA.*

reputation as an innovative architect. In 1921, Paul was officially certified to practice architecture. His first high-profile job was for Senator Frank Putnam Flint. The job was in the racially restricted suburb of Flintridge, named for the senator. Despite the racial contradictions, Paul was able to get his start designing upscale homes in the Flintridge suburb. With his growing reputation for architectural excellence and innovation, his wealthy white clientele began to expand. Paul met Louis M. Blodgett, an influential wealthy Black businessman, and designed a home for him in 1922. In 1923, Paul Williams became the first Black member of the American Institute of Architects (AIA). In 1924, Paul designed the Second Baptist Church, which was constructed by Black skilled workers from Black-owned businesses at the

insistence of the church pastor, Dr. Thomas Lee Griffin Sr. During the civil rights movement of the '50s and '60s, the Second Baptist Church hosted Reverend Dr. Martin Luther King Jr. on a regular basis.

In October 1929, the country was brought to its economic knees with the stock market crash and the onset of the Great Depression. As work began to slow down or disappear for many, Paul Williams was as busy as ever building homes for Hollywood's elites and designing important commercial projects, including the headquarters of the Music Corporation of America (MCA) (Paul Williams was given the Award of Merit from the Los Angeles chapter of the American Institute of Architects for his design of this building) and several buildings on the Howard University campus. In 1933, Paul was appointed to the Los Angeles Housing Commission. Mr. Williams wrote an autobiographical essay that was published by the *American* magazine in 1937 entitled "I Am a Negro." The editor of the magazine described the essay as the "frankest, most human discussion of the color problem we have ever read." In that same year, Paul designed the homes of Black comedic actor Eddie "Rochester" Anderson of Jack Benny fame and the world-renowned tap dancer Bill "Bojangles" Robinson.

With the beginning of World War II, Paul Williams put his talents to work in support of the war effort. In 1940, he was named by the governor of California to serve on the draft board. With the influx of newly arrived "Depression" refugees looking for work in the defense industries, the need for decent affordable housing became imperative. Paul, working with other architects, answered the call in the design and building of public housing projects in the city of Los Angeles, starting with the Pueblo Del Rio housing project, which opened in 1942. He also designed housing units, a restaurant and dormitory at Fort Huachuca, Arizona. The army base housed the Tenth Cavalry, known as the "Buffalo Soldiers," a segregated Black army unit. Paul Williams, together with other architects, designed and built the Roosevelt Naval Base project in Long Beach, California. With an eye to the future, Paul understood that there would be an influx of veterans looking for homes at the end of World War II. He wrote two books—*New Homes for Today*, published in 1945, and *The Small Home of Tomorrow*, published in 1946—in which he laid out his plans for the development of middle-class homes. Paul Williams was considered an expert in his field and was appointed to a special committee by the American Institute of Architects to serve as one of the advisers on the Cary Grant/Myrna Loy movie *Mr. Blandings Builds His Dream House*. In 1949, the headquarters building of Golden State Mutual

Paul R. Williams (*center*) with former state assemblyman Frederick Roberts on his left and attorney Charles Matthews on his right. *Miriam Matthews Collection, UCLA.*

Life Insurance Company opened to great fanfare and was the pride of the Los Angeles Black community, as was its architect, Paul Williams.

With the end of World War II, the demand for affordable single-family homes for the middle class became apparent. In Southern California, areas that had been farmland and pastures were quickly being developed into new suburban communities. Most of these new communities were hostile to prospective Black residents. Black homeowners had been restricted to older housing stock in segregated areas in Los Angeles that had been redlined by banks and the FHA. The pent-up demand for decent postwar housing in the Black community was at an all-time high. This opened the door for Black real estate broker and entrepreneur Velma Grant. Velma recognized the need for quality middle-class homes for Black residents. This "dynamic Black woman," according to Paul Williams, was able to secure a loan from Bank of America for more than $2 million and bought fifty acres of undeveloped land in the Willowbrook district of Los Angeles, bordering Compton, California. She brought in Paul R. Williams,

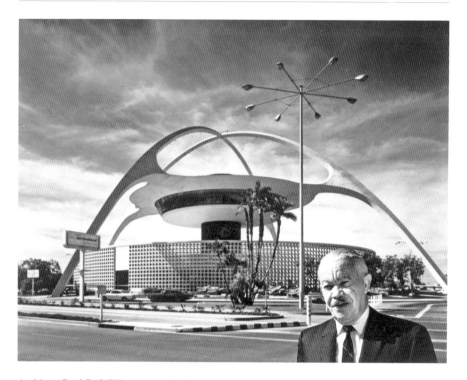

Architect Paul R. Williams was a leading member of the team that designed the Los Angeles International Airport. Here is Williams standing in front of the iconic Theme Building at Los Angeles International Airport. *Miriam Matthews Collection, UCLA.*

"architect to the stars," to design quality, well-built homes for prospective Black homeowners. Previously, the only housing available to them was older housing stock in the run-down part of town. This would be one of the first times that Black homeowners would be able to purchase newly built, modern, well-designed homes. In 1946, Carver Manor (named after the legendary Black scientist George Washington Carver) became a reality, and more than 110 of Mrs. Grant's 250 homes (she later built 90 more) were sold on the first day. With the success of Carver Manor, she repeated the process with homes designed by Paul Williams in San Bernardino, California (the Carverdale homes). The quality construction and affordability of the Williams-designed homes met the needs of the new Black middle-class homeowner.

In 1962, St. Jude Children's Research Hospital, the dream of entertainer Danny Thomas, opened its doors in Memphis, Tennessee, changing how the medical community treated children with catastrophic diseases. The hospital was designed at no cost by Paul R. Williams.

Paul Williams designed, renovated and built more than three thousand homes and commercial buildings. He received numerous awards and accolades as an architect and a human being. One has to wonder how he was able to do so much in so few years with so much opposition. Paul Williams retired in 1973 and died on January 23, 1980, at the age of eighty-five. His funeral was held at the First AME Church in Los Angeles, a building designed by the acclaimed architect Paul R. Williams.

Arnett Hartsfield

Scientists today call it HERB-1, a deadly strain of *Phytophthora infestans*. It attacks plants through the leaves. The infection seems to suck the life out of the plant, leaving it shriveled and inedible. This infection became known to the world as the cause of the Irish potato famine. By 1855, more than 2 million people had fled Ireland, with many of them coming to the United States and Canada.

George had twenty siblings when he went to sea to escape the potato famine. While sailing off of the western coast of Canada, he was struck with fever. Fortunately for him, the ship was close to shore and put him off in British Columbia, where he was nursed back to health by a young Black woman whose mother had been brought to California as a slave and left the United States for Canada to escape the constant harassment and discrimination because of her race. They fell in love and were married in Canada. Their marriage was something that could not have happened in the United States at that time.

Their third daughter, Sadie, married Arnett Hartsfield, who had been orphaned at six years old. They settled in Bellingham, Washington, where on June 14, 1918, they had a son whom they named Arnett Hartsfield Jr. As the family grew, the Hartsfields were blessed with two daughters and another son. Arnett Hartsfield Jr. described the cultural isolation he experienced growing up in Washington. "The only Black people I knew growing up were my relatives." In 1929, the Hartsfields moved to California. Arnett Jr. found California to be a revelation because it was the first time that he had Black neighbors and schoolmates. He recalled being called names by white people while he was living in Washington, but he had not been segregated until his family's arrival in California and he found himself totally unprepared for the experience. A graduate of Los Angeles's Manual Arts High School, Arnett

Trailblazing firefighter, civil rights attorney and college professor Arnett Hartsfield.

Hartsfield Jr. credited his fight to take the advanced course of the ROTC and get a commission with preparing him for the discrimination and harassment that he would later face as a leader in the fight to integrate the Los Angeles Fire Department.

After graduating from high school, Arnett Hartsfield Jr. attended the University of California–Los Angeles (UCLA), where he met and befriended fellow students Thomas "Tom" Bradley and Jackie Robinson. While a student, he also worked construction. In 1940, in order to support his new wife and eventually five children, he joined the Los Angeles Fire Department, which at the time was a segregated institution. Black firefighters were placed into one of two all-Black fire stations, Station 30 or Station 14—both located on Central Avenue and serving a predominantly Black community. Because of their segregated status, a Black firefighter could only be promoted to another Black man's position, with the rank of captain being the highest rank that a Black firefighter could achieve. That position only became open when a Black captain retired or died, making promotions for Black firefighters extremely rare.

On the morning of December 7, 1941, Arnett Hartsfield Jr. was on duty at Station 30 when he and his fellow firemen heard the news that Pearl Harbor had been bombed by the Japanese. Within months, Arnett Hartsfield Jr. was called up for military service. Because of his training in the ROTC at Manual Arts High School, he was commissioned as a United States Army lieutenant in a segregated unit and sent out to the Pacific Theater to unload ships with a Black supply unit. After the war to defeat fascism and imperialism was won, Lieutenant Arnett Hartsfield Jr. returned to his segregated job with the Los Angeles Fire Department.

With the end of World War II and the return of thousands of Black veterans hungering for the freedoms that they fought for in other

countries, many Black veterans could no longer tolerate the humiliation of segregation. A new wind was blowing, and Black men like Arnett Hartsfield Jr. were chafing under the old discriminatory laws that denied them the same opportunities as their co-workers and fellow citizens. In 1954, the United States Supreme Court decision against school segregation known as *Brown v. Board of Education* signaled the beginning of the end of state-sponsored segregation.

Working together with the National Association for the Advancement of Colored People (NAACP) and their lawyers, such as Loren Miller, Black firefighters in the Los Angeles Fire Department challenged the segregation in the department. The following year, the city reassigned eighty Black firefighters, including Arnett Hartsfield Jr., into predominately white fire stations, usually just one per shift. "They called it integration. I called it isolation," Arnett Hartsfield Jr. observed. The racial harassment and discrimination was humiliating and designed to drive the Black firefighters out of the department. Feces was smeared on one Black firefighter's pillow. "White only" signs were placed over the firehouse kitchen door. Black firemen who put their food in the firehouse refrigerator would frequently find that their food had been urinated on. Arnett was told by his captain not to eat in the kitchen while white firemen were there. "For five years I ate after they were through," he recalled. In an effort to protect themselves from the physical threats and harassment, a group of about thirty Black firemen, led by Arnett Hartsfield Jr., formed a support group called the Stentorians (taken from the Greek word *stentor*, a powerful voice). Because of the physical threats and harassment, some of the Black firemen began to arm themselves for protection. Racism and harassment were especially blatant at Station 10, which was located in downtown Los Angeles. The Stentorians formed a twenty-four-hour patrol to help protect the Black firemen on duty at that fire station. Stentorians armed with special microphones provided by local CBS affiliate Channel 2 news recorded the racial harassment and intimidation of the Black firefighters at Station 10.

The fire chief at the time, John H. Alderson, was a rabid segregationist and was resistant to the efforts to integrate his department. The motto of the white resistance was "And then there were none," in reference to their strategy of racist harassment to the point where life at the firehouse would be intolerable for Black firemen, who would then be forced to leave their jobs. Of course, racism is a double-edged sword. Fireman Reynaldo Lopez, a Black firefighter who was determined to stick it out no matter what happened, was pleasantly surprised on his first day at Station 46 on West

Vernon Avenue. He remembered the acting captain, G. Keith Kenworthy, and the other men on that shift welcoming him to the station. By the next shift, when Lopez reported back to work, the white men who had welcomed him the first day had all been transferred to other stations, including Captain Kenworthy. Their crime had been showing kindness and welcoming a Black fellow firefighter to the station. This was perceived as an intolerable act of treason by the chief. The new group ignored him except to insult and harass him. During lineups, the captain assigned him to a spot away from the rest of the company. His bed was put behind the door leading to the dormitory; the men would bang the door open and shut while Lopez was trying to sleep. On June 24, 1955, a sign appeared on the door that led to the firehouse kitchen. The sign read, "White adults." When Lopez saw the sign, he called Arnett Hartsfield Jr., who drove to the station and gave a camera to Lopez so that he could take a picture of the sign. Hartsfield gave the picture to local television news reporter Bill Stout, who had been reporting on the integration efforts at the Los Angeles Fire Department. When Lopez spoke to his captain about the sign, the captain refused to take it down, telling him, "You know you're not wanted here." That evening, Bill Stout ran the story with the picture on the local CBS affiliate, describing the campaign of racial discrimination and harassment that the local Black firemen had to endure.

The Los Angeles Fire Department struck back. It brought Lopez up before a board of chiefs, accusing him of putting the sign up himself and photographing it. The board also claimed to have a witness who saw him do it, a civilian dry cleaner who was backed up by the rest of the crew. Bill Stout testified at the hearing with a copy of the picture, according to Lopez. He questioned the civilian as to what time of the day the photo was taken. The guy said that it was four or five o'clock. Bill was able to point out that the shadowing on the photograph indicated the position of the sun at the moment the photo was taken. The photo was taken at noon. "This made a liar out of the witness," Lopez said. "I believe Bill Stout saved my job." Even though the charges were dropped, the campaign to harass Lopez out of the station got worse. But Lopez stayed with the fire department for twenty-eight years with the help of his fellow Black firefighters and the Stentorians, whose current headquarters is at 1409 West Vernon Avenue in Los Angeles, California, the site of Station 46, where Lopez withstood years of racial harassment and torment. Lopez noted that Captain Kenworthy was harassed and eventually lost his job for insubordination because he refused to go along with the program of racial harassment of Black firefighters. In 1973, Arnett Hartsfield Jr. and

City Councilman Billy Mills published *The Old Stentorians*, a record of the injustices and the fight to integrate the Los Angeles Fire Department.

Using the GI Bill, Arnett Hartsfield Jr. attended USC Law School, earning his law degree in 1955, but at the station house he was regulated to cleaning toilets as the white firefighters taunted him by referring to him as "Calhoun," a reference to the fast-talking buffoon of a lawyer featured on the television show *Amos 'n' Andy*. In 1961, Arnett Hartsfield Jr. retired from the Los Angeles Fire Department and began to practice law full time. He eventually became a professor in the Black Studies Department at California State University at Long Beach, where he taught for twenty-six years. In 1997, he was instrumental in opening the African American Firefighters Museum in the newly renovated Station 30 on Central Avenue, where he volunteered three days a week until just before his death in October 2014. In 2008, Arnett Hartsfield Jr. received the Los Angeles Fire Department's first lifetime achievement award, presented to him by Douglas Barry, the department's first Black fire chief.

Arnett Hartsfield Jr. transitioned from this life to a new adventure on October 31, 2014, at the age of ninety-six. The Los Angeles Fire Department honored the memory of Hartsfield with a hero's funeral that included a helicopter flyover in the missing man formation. Speakers included dignitaries from the Los Angeles Fire Department and the mayor of the city of Los Angeles. In attendance were hundreds of firefighters, friends, family and his wife, Jeanne. It was truly an impressive celebration of his life.

A CHANGE IS GOING TO COME

FREDERICK ROBERTS

When we think of the third president of the United States, Thomas Jefferson, we think of the author of the Declaration of Independence, a founding father of the United States of America, a member of the Continental Congress and the governor of Virginia. Historians have considered President Jefferson a "Renaissance man," with an interest in the arts and sciences, as well as a man with a philosophical mind. Through his writings, Jefferson expressed a disdain and opposition to the institution of slavery, yet he owned several hundred slaves, including several he had fathered with his slave Sally Hemings. Sally was Thomas Jefferson's wife Martha's younger

Reverend Clayton D. Russell, the progressive pastor of the People's Independent Church of Christ and warrior for equality and justice, sending out a call for support for a community-owned supermarket in the Los Angeles Black community. From *Who's Who in California from the California Negro Directory, 1942–1943. Miriam Matthews Collection, UCLA.*

enslaved half-sister. Sally, also known as Sarah Hemings, was the offspring of Martha Wayles (Skelton) Jefferson's father, John, and an enslaved woman, Elizabeth "Betty" Hemings.

Ellen Wayles Hemings was the daughter of Madison Hemings, a carpenter by trade. He was trained on the violin in his youth and was one of the younger sons of Sally Hemings. The 1870 United States Census lists Madison Hemings as the son of President Thomas Jefferson. In a memoir published in 1873, Madison Hemings named Thomas Jefferson as his father. Ellen, the granddaughter of Sally Hemings and President Thomas Jefferson, married Andrew Jackson Roberts of Chillicothe, Ohio. On September 14, 1879, they had a son named Frederick Madison Roberts. Six years later, the family moved to Los Angeles, California, where Andrew Jackson Roberts established the first Black-owned mortuary in the city,

California state assemblyman Frederick Roberts and Joseph Bass—"race man," husband to Charlotta Bass and a crusading journalist for equal rights. *Miriam Matthews Collection, UCLA.*

A.J. Roberts and Son. The Roberts family soon had a second son, William Giles Roberts. The family soon became prosperous and well known in the Los Angeles Black community.

Andrew Jackson Roberts was a graduate of Oberlin College and established a strong sense of public service and education in his sons. Frederick Roberts became the first Black person to graduate from Los Angeles High School. He attended the University of Southern California and continued his studies at Colorado College. While in Colorado, he served as deputy assessor for El Paso County. He also attended the Barnes-Worsham school of embalming and mortuary science. This training proved invaluable when he eventually took over his father's lucrative mortuary business. After graduation, Frederick Roberts took a job in Mississippi as principal of the Mound-Bayou Normal and Industrial Institute. Mound-Bayou, Mississippi, was founded in 1887 by Black freemen led by Isaiah Montgomery. The community was praised by Booker T. Washington as a "model of self-sufficiency."

Frederick Roberts returned to Los Angeles in 1912 and founded the *New Age Dispatch* newspaper. The name was later shortened to *New Age*, and it became a very influential newspaper in the Black community. The newspaper and Frederick's association with the National Association for the Advancement of Colored People and other civic and church organizations brought him into the political arena and the fight for equality. According to Pearl Roberts, Frederick Roberts's wife, "He did not like the word 'Negro.' He used the term 'Americans of African descent.' He wanted to stress the fact that we were Americans and should be treated as Americans. Whereas most newspapers would say, 'another Negro lynched,' his newspaper would say, 'another American lynched.'"

Frederick Roberts ran for a seat on the board of education and lost. In 1918, he ran for the California Assembly. His opponent in that race handed out business cards to potential voters that simply read, "My opponent is a nigger." Mr. Roberts's campaign strategy had much more substance, and after a hard-fought campaign, he was elected to the California State Assembly representing the Sixty-Second District as a Republican. Mr. Roberts was the first Black man to be elected to a state government position west of the Mississippi in the twentieth century. As a legislative assemblyman, Roberts sponsored legislation in favor of public education, civil rights and anti-lynching laws. He was also instrumental in the establishment of the University of California–Los Angeles. He met with national Black leaders such as Dr. W.E.B. Du Bois and Marcus

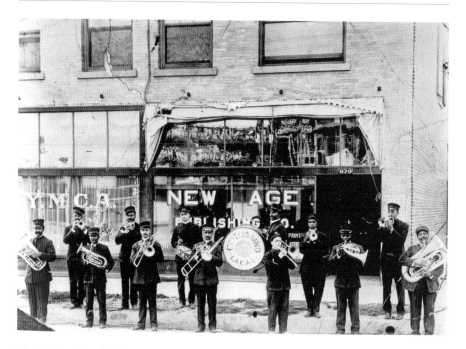

The Citizens Band of Los Angeles, California, plays in front of Frederick Roberts's *New Age* newspaper office. *Miriam Matthews Collection, UCLA.*

Garvey when they visited Los Angeles. In 1921, Frederick Roberts married Pearl Hinds, and together they had two daughters: Gloria, who became a classical pianist, and Patricia, who became a Los Angeles businesswoman. Overcoming discrimination and racial harassment even in the California Assembly, he became an effective legislator and representative for the Sixty-Second District. He served for sixteen years and became known as the "Dean of the Assembly" until he was defeated in 1934 by Augustus F. Hawkins, a New Deal Democrat. After running twice unsuccessfully for the local Congressional seat, Mr. Roberts continued as a Republican Party activist, attending the 1952 Republican National Convention. A few days after returning from the Republican Party convention in Chicago, Illinois, Mr. Roberts was seriously injured in a car accident in front of his Jefferson Boulevard home. He died the next day, July 19, 1952. In 1957, the City of Los Angeles dedicated Frederick M. Roberts Park, located at 4700 Honduras Street.

AUGUSTUS F. HAWKINS

Augustus Freeman Hawkins was born in Shreveport, Louisiana, on August 31, 1907. He was the youngest of five children born to Nyanza and Hattie Hawkins. Mr. Hawkins was a prosperous pharmacist in the Jim Crow South. As part of the historic Black migration out of the South, the Hawkins family left Louisiana to find opportunity in Los Angeles, California, in 1918. Young Augustus, known to everyone as "Gus," had been affected by the racist Jim Crow laws even as a young boy. Augustus was very fair-skinned and was often mistaken for white. He recalled a time when he would ride the streetcars in Shreveport and would sit toward the back only to have the conductor move the "Negro only" sign behind him so that he would be in the white section. "I got so angry with the whole thing and embarrassed that I would just walk," he recalled. These racial indignities politicized Augustus at an early age.

After his family arrived in Los Angeles, Augustus Hawkins graduated from Thomas Jefferson High School and soon earned a bachelor's degree in economics from the University of California–Los Angeles in 1931. Young Augustus had planned to go on to graduate school to study civil engineering, but his plans were changed by the Great Depression. He went into real estate with his brother Edward and soon became interested in politics. In 1932, he supported Franklin D. Roosevelt for president. In 1934, he supported the gubernatorial campaign of Upton Sinclair, the famous author of *The Jungle*. That same year, he challenged longtime Black Republican assemblyman Frederick Roberts for his seat in the California Assembly and won as a "Roosevelt Democrat."

As a member of the California Assembly, Assemblyman Hawkins legislated for a fair employment practices act, a fair housing act, disability insurance and workmen's compensation for domestic workers. He became known as a champion for equal rights. In August 1945, Assemblyman Augustus Hawkins married Pagga Adeline Smith. In 1958, he lost a bid to become Assembly Speaker to Ralph Brown of Modesto, who promptly appointed Hawkins to chair the powerful rules committee. In 1962, Hawkins ran for the newly created Black majority Congressional district that encompassed most of his old assembly district. Hawkins would say, "I felt that as a Congressman I could do a more effective job than in the Assembly." With an endorsement from President John F. Kennedy and with his sterling civil rights record, Augustus Hawkins easily won the Congressional seat, becoming the first Black person to win a Congressional seat west of the Mississippi. Congressman Hawkins

remarked after the election, "It's like shifting gears, from the oldest man in the Assembly in years of service to a freshman in Congress."

Congressman Hawkins worked tirelessly for equal rights and an end to government-sponsored racial segregation. His commitment to the improvement of the quality of life for Black people and other minorities led him on a 1964 Congressional fact-finding mission to the South with three white Congressmen to observe firsthand the disenfranchisement, discrimination and poverty that was commonplace in southern states. One of Congressman Hawkins's early legislative accomplishments was the establishment of the Equal Employment Opportunity Commission, a federal agency to fight discrimination in the workplace as part of Title VII of the Civil Rights Act of 1964. He believed that there was more work to be done, as he described the bill, "It is incomplete and inadequate; but represents a step forward." As a neophyte congressman, Hawkins was thrust into the limelight, as part of his district was virtually under martial law during the Watts rebellion of August 1965. He publicly blamed Los Angeles mayor Samuel Yorty for withholding federal anti-poverty funds and Los Angeles police chief William Parker for his brutally racist tactics in the Black community. He told his fellow lawmakers, "The trouble is that nothing has ever been done to solve the long-range underlying problems." Congressman Hawkins worked tirelessly to bring federal funds to help rebuild the infrastructure and improve the quality of life in Watts.

As part of Congressman Hawkins's legacy, it should be noted that he corrected a historic wrong. He obtained an honorable discharge for the 167 Black soldiers who were dismissed from the United States Army after being falsely accused in a racial shooting incident in Brownsville, Texas, in 1906. He also was a founding member of the Congressional Black Caucus and served as its first vice-chairman. Congressman Hawkins's political pragmatism was viewed as out of step by some of the more militant Black leadership, but he would argue, "We need clearer thinking and fewer exhibitionists in the civil rights movement." Congressman Hawkins knew that he had to form alliances with different groups in order to be effective in Congress. His commitment to freedom and justice was not always easy. He was a supporter of President Johnson's "Great Society" legislation, and he initially supported President Johnson's position on South Vietnam but soon became a vocal critic. Congressman Hawkins's criticism of the war in Vietnam reached a high point after his visit in 1970 to South Vietnam, where he witnessed the inhumane treatment of civilian prisoners, men, women and children by the South Vietnamese government.

In the 1970s, Congressman Hawkins championed legislation for the poor and the middle class. The Comprehensive Employment and Training Act of 1978 gave many teenagers and young adults their first opportunity in the working world. The Pregnancy Disability Act protected women from being discriminated against on the job because of a pregnancy. Congressman Hawkins's best-known legislation was the Humphrey-Hawkins Full Employment Act, which he sponsored alongside former vice-president Senator Hubert Humphrey. Hawkins also authored the Job Training Partnership Act and the School Improvement Act. His legislative aims were clearly an attempt to improve the lives of his constituents.

With the election of Ronald Reagan in 1980, support for "New Deal" or "Great Society" programs began to wane. The new Republican economic philosophy of "trickle-down economics" was not compatible with those programs. When President George H.W. Bush vetoed the Hawkins-Kennedy Civil Rights Act in 1990, it became the only successful veto of a civil rights act in the country's history.

Congressman Augustus F. Hawkins retired from public life in 1991. His open Congressional seat was won by Maxine Waters. In 2012, the Augustus F. Hawkins High School was opened in Los Angeles. The Augustus F. Hawkins Natural Park was opened in 2000. Congressman Augustus F. Hawkins died in Washington, D.C., at the age of one hundred on November 10, 2007. He was survived by his second wife, Elsie Taylor Hawkins, and two stepdaughters.

DR. MERVYN M. DYMALLY

In 1498, Christopher Columbus was on his third voyage to the New World when he landed on an island off of the coast of South America that he would name Trinidad (Trinity). The island was colonized by the Spanish, who tried to enslave the indigenous people; not being totally successful in that venture, they became the first to bring enslaved Africans to the island. Trinidad was also colonized by the Dutch and the French. In 1797, the British took over the island, which by then had a large enslaved African population. In 1807, the slave trade was abolished. In 1816, seven hundred formerly enslaved Africans from the southern United States who had escaped from bondage and fought alongside the British in the War of 1812 were brought to the island and given land as a reward for their service in the British army. In 1838, the institution of slavery was ended on the island. The end of slavery

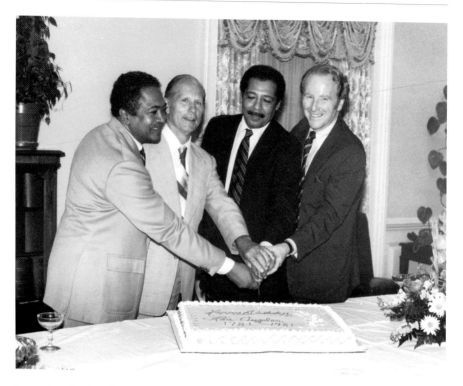

Legendary Black politician and former California lieutenant governor Mervyn Dymally (*far left*), Glenn Anderson, Julian Dixon and Bob Dornan celebrating Los Angeles's 200th anniversary (1781–1981).

brought about a shortage of labor, which caused the plantation owners to begin importing workers from China, India and West Africa until 1917. This history left the island of Trinidad with a very diverse population.

Born in a small village outside Cedros, Trinidad, on May 12, 1926, to a Muslim father of Indian descent, Hamid, and an Afro Trinidadian mother, Andreid (née Richardson), who was a Roman Catholic, Mervyn Malcolm Dymally, the third of nine children, was welcomed into the world by a loving family. After graduating from secondary school and taking odd jobs, he began working as a reporter for the *Vanguard*, a labor newspaper published by the Oil Workers' Union. He reported on labor activities and participated as a labor organizer. Inspired by a book he found about Booker T. Washington, he set his sights on obtaining an education in the United States to study journalism. Arriving at Lincoln University in Jefferson City, Missouri, Mervyn began his academic career in this country. After a semester at Lincoln University, Mervyn moved to Los Angeles, California,

and attended Chapman University before completing a Bachelor of Arts degree in education at California State University, Los Angeles, in 1954. He began teaching in the Los Angeles Unified School District. He later earned a master's degree in government from California State University–Sacramento in 1969 before earning his doctorate in human behavior from United States University in San Diego in 1978. For Dr. Mervyn Dymally, education was a lifelong pursuit.

Inspired by the presidential campaign of John F. Kennedy, Mervyn Dymally became a field coordinator for the Kennedy campaign and soon became a leader in the Los Angeles Black political establishment of the early 1960s. Mervyn ran for the California Assembly in 1962 and won the seat that was formerly held by Augustus Hawkins, who had just won a seat in the United States House of Representatives. According to California State University–Los Angeles political scientist Raphael Sonenshein, "Dymally built one of the most important Black political organizations in Los Angeles." In 1966, Mervyn Dymally became the first Black person in the twentieth century to be elected to the California Senate, where he championed many progressive causes, including the Equal Rights Amendment. State Senator Dymally authored legislation to reduce the voting age to eighteen and sponsored legislation to fund the teaching of Black history in public schools. He also sponsored or supported legislation in support of early childhood education and the creation of the California African American Museum, Cal State University–Dominguez Hills and the Charles R. Drew medical school in Watts, to name but a few.

In 1974, State Senator Mervyn M. Dymally was elected lieutenant governor of the state of California, becoming the first Black person to hold that office. As lieutenant governor, he focused on a progressive agenda that included equal rights for women, environmental issues and access to education and healthcare for poor communities. In 1978, Lieutenant Governor Dymally lost his reelection campaign to Republican Mike Curb. With lackluster support from the Democratic Party, Dymally was still poised to win the election until an aide for Republican George Deukmejian, Michael Franchitti, sabotaged Dymally's campaign with a false rumor. Days before the election, Franchitti leaked a fraudulent report to the Curb campaign and to a local television reporter that Lieutenant Governor Mervyn Dymally was about to be indicted by the U.S. Department of Justice on corruption charges. The report was false (some would say a deliberate lie meant to derail the lieutenant governor's campaign at the last minute), but the charge was reported just days before the election, making it impossible for the Dymally

campaign to rebut the charge before the election. A letter of reprimand was later put into Michael Franchitti's personnel records by Attorney General Evelle Younger, accusing him of a breach of responsibility.

In 1980, after earning his PhD, Dr. Dymally was elected to the United States House of Representatives. As congressman for the Thirty-First Congressional District, he served on the foreign affairs committee and chaired the subcommittee on international operations. He also chaired the subcommittee on judiciary and education. He served as chairman of the Congressional Black Caucus from 1987 to 1989 and sponsored a progressive legislative agenda that included progressive international policies directed toward the African nations and the Caribbean. As an advocate for human rights and building trade relations, he met with international leaders from the Middle East, the Caribbean and Africa, advocating economic development. He criticized the South African apartheid government and was a strong advocate for sanctions. He took up the cause of Haitian immigrants and was a supporter of an independent Palestinian state. He was a critic of Ronald Reagan's foreign policy in South America, especially the administration's aid to the Nicaraguan Contras. In 1991, Congressman Dymally was appointed by President Bill Clinton to serve as a representative to the United Nations.

Dr. Dymally retired from Congress in 1992 and was named honorary consul to the Republic of Benin in 1993. He went back to his roots as an educator and served as a distinguished professor at Central State University in Ohio. He also served on the faculty of Charles R. Drew University of Medicine and Science in the Watts section of Los Angeles. Disappointed with the caliber of the candidates who were running for his old state assembly seat, Dr. Dymally decided to throw his hat into the ring. He won the nomination and the seat in 2002. He held the seat until 2008, when he lost the election for a state senate seat. When asked, Congressman Julian Dixon of Los Angeles said that Dr. Dymally's legacy would be as "a mentor, responsible, in part, for a lot of elected people in the Black community." As for his controversial political career, Dr. Dymally said, "I do not seek to be popular. I seek to be right." Dr. Mervyn Malcolm Dymally died on October 7, 2012, in Los Angeles, California. The Mervyn M. Dymally Nursing School on the Charles R. Drew University campus, the Mervyn M. Dymally High School in Los Angeles and the Mervyn M. Dymally African-American Political and Economic Institute at Cal State University–Dominguez Hills are all named in his honor.

Thomas "Tom" Bradley

In April 1917, the United States of America entered World War I because, according to President Woodrow Wilson, "the world must be made safe for democracy." On July 2 of that year, Black men, women and children were gunned down on the streets of East St. Louis by armed white mobs. Others were burned alive in their homes or were met with volleys of deadly gunfire as they tried to escape their burning abodes. Some were lynched, strung up to lampposts, their homes burning in the background—survivors were taunted and threatened by angry white mobs. This atrocity was known as the East St. Louis Race Riot, a precursor to the Bloody Summer of 1919–20.

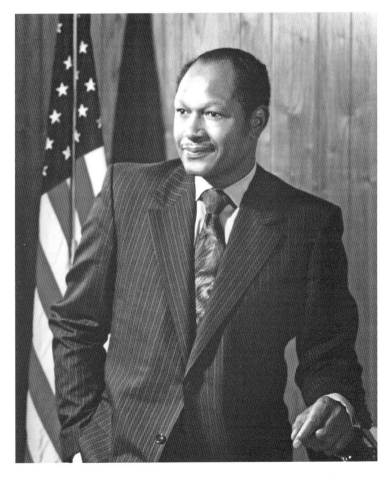

Portrait of Mayor Thomas Bradley, first Black mayor of the city of Los Angeles under American rule.

On August 23, 1917, members of the segregated all-Black Twenty-Fourth United States Army Infantry Regiment armed themselves to face down local white police officers and armed white citizens, who had harassed and attacked members of the regiment, which was stationed at Houston, Texas, to guard the Camp Logan construction site. When the smoke cleared, four Black soldiers, five policemen and twelve civilians had been killed. After a court-martial, nineteen Black soldiers were executed, and forty-one were given life sentences—no white participant was ever tried in a court of law.

Just 128 miles from Houston, Texas, in rural Calvert, Texas, Thomas "Tom" Bradley was born on December 29, 1917, the grandson of a slave and the son of a poor sharecropper named Lee Thomas Bradley and his wife, Crenner. Tom had four siblings: Lawrence, Willa Mae, Ellis and Howard. In 1924, when Tom was seven years old, his family became part of the historic Black migration out of the South in an effort to escape the racial terror, intimidation and discrimination that was a way of life in "Jim Crow" Texas. Once in Los Angeles, California, Tom's father, Lee, found work as a porter on the Santa Fe Railroad; his mother was employed as a maid. Young Tom attended school, eventually graduating from Polytechnic High School, where he played football and was the captain of the track team. Receiving an athletic scholarship, he attended UCLA in 1937 and participated on the school's track team along with a teammate from Pasadena named Jackie Robinson. While in college, he worked as a photographer for well-known comedian Jimmy Durante and became a member of the Kappa Alpha Psi fraternity, eventually becoming the fraternity's national president.

In 1940, Thomas Bradley joined the Los Angeles Police Department. According to an interview conducted by the *Los Angeles Times*, Officer Bradley was dismayed that he was still refused credit at downtown department stores and would be denied service at restaurants even while wearing his uniform. According to a *Times* interview, Tom Bradley noted that as a police officer, he was restricted to patrolling the Black community along Central Avenue in the Newton division or performing traffic duty downtown. He could not work with a white officer until after 1964. (Jack Webb never talked about that rule on *Dragnet*.) In 1941, Tom Bradley married Ethel Mae Arnold, and they were blessed with two daughters, Lorraine and Phyllis. Officer Bradley, who developed a reputation for outrunning and catching fleeing suspects instead of shooting them down, stayed with the police department for twenty-one years, retiring with the rank of lieutenant, the highest position that a Black police officer could attain with the Los Angeles Police Department at that time. After years of attending Southwestern Law School at night, he passed

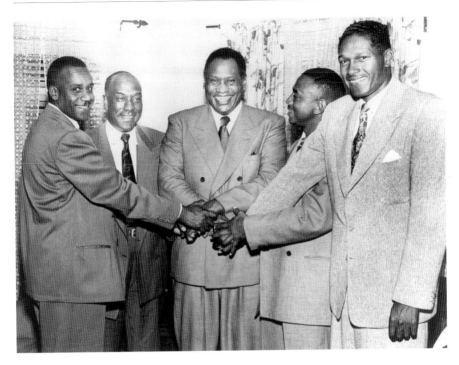

Thomas "Tom" Bradley (*right*) with the iconic humanitarian and human rights leader Paul Robeson (*center*). *Miriam Matthews Collection, UCLA.*

the bar on his first try in 1956 and in 1962 was ready to explore a new career as a lawyer, or so he thought.

In 1949, Tom Bradley worked as a volunteer in the Los Angeles City Council campaign of Edward Roybal. As a police officer, Bradley was the first head of the Los Angeles Police Department's community relations department. In this capacity, he was able to meet influential leaders in the community. He also participated in different Democratic Party organizations, working with liberal white, Hispanic, Asian and Jewish community leaders. These groups would make up the coalition that would one day sweep him into the mayor's office. In 1963, Bradley was elected to the Los Angeles City Council, becoming the first Black "elected" city council member in the twentieth century. Black city council member Gilbert Lindsay had been sworn in a few months earlier as an "appointed" member of the city council.

While on the city council, Tom Bradley was a critic of Chief William Parker's Los Angeles Police Department. He was especially critical of the way Chief Parker handled the 1965 Watts rebellion. City Councilman Bradley's assessment of the Los Angeles Police Department under the

leadership of Chief Parker was that "some police officers are bigoted. It is not a majority, but a small minority. I think the public should be aware of it. I think there is obvious segregation in the Los Angeles Police Department." The 1960s were a turbulent time in Los Angeles. After the Watts rebellion, several grassroots militant organizations became active in Los Angeles. An election year, 1968, brought the assassination of Dr. Martin Luther King Jr. in April in Memphis, Tennessee. There were antiwar demonstrations, and in June, Robert F. Kennedy was assassinated at the Ambassador Hotel in Los Angeles. August 25, 1968, saw the police killings of three members of the Black Panther Party—Steve Bartholomew, Robert Lawrence and Tommy Lewis—at Adams and Montclair in Los Angeles. More than twenty thousand Chicano students staged a walkout of East Los Angeles schools, protesting racism and discrimination in the school district. These events and the January 17, 1969 FBI-inspired assassinations of Al Prentice "Bunchy" Carter and John Jerome Huggins, two leading members of the Southern California chapter of the Black Panther Party, at the University of California–Los Angeles made it certain that the municipal race for mayor of Los Angeles in 1969 would be pivotal.

Sam Yorty was the incumbent mayor of Los Angeles in 1969. Yorty was first elected mayor in 1961, a conservative Democrat and anti-Communist; he stood against school desegregation and was critical of civil rights leaders. He believed that the Watts rebellion of 1965 was actually caused by "communist agitators" rather than constant racial harassment and brutality by the Los Angeles Police Department, a host of social ills and willful neglect by city hall. He was accused by leaders of the Black community of withholding federal anti-poverty funds that were sorely needed in economically depressed areas of Los Angeles such as Watts. In 1966, Mayor Yorty, who was defeated in the Democratic primary for governor, supported Republican Ronald Reagan over the incumbent Democratic governor Edmund G. Brown. In 1968, Mayor Yorty would not support Democratic vice president Hubert Humphrey in his campaign against Richard Nixon for the presidency.

By 1969, Mayor Sam Yorty's political support was waning as he faced Los Angeles city councilman Tom Bradley in a runoff election for mayor. Yorty chose political financier and arch-conservative political activist Henry Salvatori to run his campaign. Bradley was polling ahead of Yorty early in the campaign. Yorty's campaign countered with an aggressively racist campaign designed to instill fear of a Bradley administration in the white community. The Yorty/Salvatori campaign strategy worked, ensuring Mayor Yorty four more years in the mayor's office. Four years later, in 1973,

Mayor Yorty's racial campaign appeal could not keep him in office. Mayor Thomas "Tom" Bradley won the office with his multiracial coalition. His administration welcomed underrepresented minorities and women to city hall. He reconstructed the downtown financial and business sectors with a new skyline. Under Mayor Bradley's leadership, Los Angeles became an international city, hosting the 1984 Olympics, the first Olympic Games to turn a profit. During Mayor Bradley's term, Los Angeles took its place as a leader in international trade.

Mayor Bradley ran for governor of California in 1982 and again in 1986, losing to George Deukmejian in both contests. The 1982 election was extremely close, and many of the polls projected Bradley as the winner, with Bradley ultimately losing by 100,000 votes out of 7.5 million cast. The pollsters began to realize that some of the white voters whom they interviewed, while saying that they were undecided or were going to vote for the Black candidate, actually voted for the white candidate. Not wanting to appear to be racist against the Black candidate, they gave false answers—this attitude became known as the "Bradley effect." Mayor Bradley's long struggle with racism in the Los Angeles Police Department came to a head with Police Chief Daryl Gates, a protégé of former police chief William Parker. In 1991, several Los Angeles police officers were videotaped brutally beating motorist Rodney King. The trial of the Los Angeles police officers was moved from the downtown Los Angeles courthouse to a courthouse in the Los Angeles suburb of Simi Valley near the border of Ventura County. Predictably, the officers were found not guilty despite the video. The community, in its outrage, erupted in what would be called the "Rodney King riots" for six days. The aftermath of this event would lead to the end of Chief Daryl Gates's career with the Los Angeles Police Department and cause Mayor Bradley not to seek a sixth term as mayor of the city of Los Angeles. Mayor Thomas Bradley is the longest-serving mayor of the city of Los Angeles.

In March 1996, Bradley suffered a heart attack. After a triple bypass operation, he later suffered a stroke. He died on September 29, 1998, at the age of eighty and was interred at Inglewood Park Cemetery after his body lay in state for public viewing at the Los Angeles Convention Center. Mayor Tom Bradley was a true champion of Democratic values. One can say that he was among those who truly tried to make America safe for democracy.

AL PRENTICE "BUNCHY" CARTER

Southern California Chapter of the Black Panther Party

The United States' entry into World War II following the surprise attack at Pearl Harbor on December 7, 1941, had a profound effect on the Black community in Southern California. The development of the defense industries on the West Coast brought millions of southern migrants to urban areas along the West Coast.

A. Philip Randolph and other Black leaders such as Walter White had threatened a march on Washington, D.C., to protest racial discrimination in defense plants and the military. On June 25, 1941, just months before the attack on Pearl Harbor, President Franklin D. Roosevelt signed Executive Order 8802, outlawing racial discrimination in defense plants, signaling to millions of Black southerners living under the oppressive restrictions of "Jim Crow" segregation laws that new opportunities to make a living wage were available outside the South. Tens of thousands of Black southern migrants arrived in Los Angeles, many of them crowding into segregated Black neighborhoods that were already overcrowded with people living in substandard housing.

As many hopeful Black families found work in the promised land of Los Angeles, California, a city supposedly free of state-sponsored "Jim Crow" laws, many Black people became familiar with a new racist phenomenon, "James Crow Esquire," a more subtle and insidious California type of segregation and discrimination. One of those southern migrants was Elmore "Jack" Carter of Shreveport, Louisiana. A carpenter by trade, he found very lucrative work in Los Angeles. By 1945, he sent for his wife, Nola Mae Carter, and their four children to begin their new life in postwar Los Angeles. Soon, six more children were born, and the Carter family expanded to eight sons and two daughters. Mrs. Carter was a stay-at-home mother who loved poetry and instilled in her children the common-sense lessons of survival that she learned from her parents in "Jim Crow" Louisiana. She knew that even though there were no signs that said "white only" or "colored only" in Los Angeles, she understood the concrete reality. "You have to be dumb and blind not to understand that it's segregation, but it doesn't say so....They don't call it segregation, but that's what it is. You go to school in your district." And these rules were rigidly enforced by local law enforcement and white youth gangs, the most notorious of which was known as the "Spook Hunters."

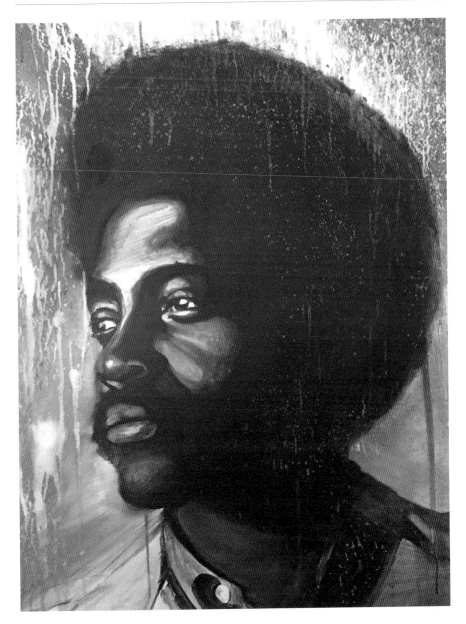

Painting by the artist "EnKone" of the legendary Black Panther Party leader Al Prentice "Bunchy" Carter. *Courtesy of "EnKone."*

The Spook Hunters were white teenagers who formed an organized resistance to Black integration of neighborhoods and schools in the predominately white communities that surrounded an overcrowded and

segregated Black community. This group was regularly supported by the local police departments in these neighborhoods. The Spook Hunters could be found in the surrounding cities of Southgate, Lynwood, Compton and Inglewood. In the late 1940s, the gang was involved in the racial disturbances at Fremont High School. According to Raymond Wright, a founder of a Black street club known as the "Businessmen," based at South Park in Los Angeles, "You couldn't pass Alameda, because those white boys in Southgate would set you on fire." As a result, Black youth formed different street clubs for protection. One of the largest and most notorious was known as the Slausons, named after a street that had been the southern boundary of the Black community. By the late 1950s, one of the leaders of the hard-core inner circle of the Slausons, known as the "Renegade Slausons," was Al Prentice "Bunchy" Carter, the son of Elmore "Jack" and Nola Mae Carter. According to Bunchy's mother, he got the nickname from one of his grandmother's friends: "One of mama's friends....He was real plump when he was a baby, and she came and she started to calling him Bunchy. And that's how he got Bunchy"—like a bunch of greens.

Al Prentice "Bunchy" Carter was born on October 12, 1942, in Shreveport, Louisiana, and grew up in Los Angeles, California. A smart, handsome young man and a natural leader, he became well known and well liked by the time he graduated from Fremont High School. He was known as a serious young man who didn't tolerate fools lightly. At age fifteen, Bunchy was exposed to the Nation of Islam when Malcolm X came to Los Angeles and established Temple 27. It wasn't until Bunchy was incarcerated for bank robbery in the early 1960s that he joined the Nation of Islam. While in prison, he met Eldridge Cleaver, who was also a member of the Nation at that time. While in prison, Cleaver and Carter, both of whom were disciples of Malcolm X, planned to form an organization much like Malcolm X's Organization of Afro American Unity once they got out of prison. When Eldridge Cleaver was released from prison and working as a writer for *Ramparts* magazine, he met Huey P. Newton and Bobby Seale and soon joined the Black Panther Party. Upon Bunchy's release, Eldridge Cleaver introduced Bunchy Carter to Huey and Bobby, and he joined the organization on the spot. This was in 1967.

Bunchy was tasked with organizing a Southern California chapter of the Black Panther Party. According to Roland Freeman, one of the first members of the Southern California chapter of the Black Panther Party and a survivor of the five-hour police attack on the Los Angeles Black Panther Party headquarters in December 1969, Bunchy Carter transformed himself

while he was in prison: "He was a brilliant man. He was a natural leader, plus he knew history. He was a poet. He wrote poems. He could fight, he could dance. Once he had politicized the revolution inside himself, he became a different individual. Bunchy Carter was the Black Panther Party in L.A., and L.A. was one of the strongest chapters in the Black Panther Party." Under Al Prentice "Bunchy" Carter's leadership, the Southern California chapter of the Black Panther Party would stretch from Los Angeles to San Diego. Many former gang members and Black youth in general who had become politicized after the Watts rebellion were looking for a new political vehicle that they could relate to. The Southern Christian Leadership Conference, the NAACP and the Urban League were viewed by Black youth as an ineffective old guard. Ron Karenga formed the cultural nationalist organization known as US right after the Watts rebellion of 1965. Late in 1967, Bunchy Carter began organizing the Southern California chapter of the Black Panther Party. Carter was a former leader of the five-thousand-strong Slausons street gang, and many members of that organization who had become politicized joined the Black Panther Party under Bunchy's leadership, including students and other Black youth who had become radicalized after the 1965 Watts rebellion. Some of the notable members of the Southern California chapter of the Black Panther Party were Elaine Brown, Masi Hewitt, Judge Joe Brown, Ronald and Roland Freeman, Deacon Alexander, Angela Davis, Ericka Huggins and Geronimo Pratt.

In March 1968, Bunchy Carter's brother Arthur Glenn Morris was killed, becoming the first member of the Black Panther Party to be murdered. Another blow to the Southern California chapter of the Party came with the killing of three Party members—Tommy Lewis, Robert Lawrence and Steve Bartholomew—by the Los Angeles Police Department in a gas station at Montclair and Adams on August 25, 1968. At the same time, tensions were being created between Ron Karenga's US organization and the Southern California chapter of the Black Panther Party—poison pen letters that warned of planned attacks on the Black Panther Party by members of the US organization and vice versa, mysterious threatening calls and cartoons made to look like they were sent from the US organization ridiculing and threatening the leadership of the Black Panther Party. The same tactics were used to increase tension within the US organization's rank and file, with the intention to incite violence against each organization. Bunchy Carter issued Executive Order 1, which made it clear to the rank-and-file Black Panther Party members that other Black organizations were not the enemy.

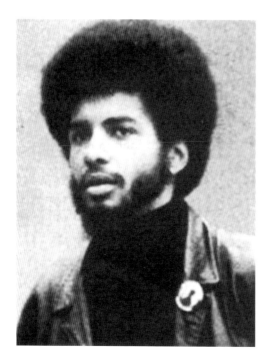

John Jerome Huggins, Deputy Minister of Information of the Southern California chapter of the Black Panther Party, was assassinated at UCLA alongside Al Prentice "Bunchy" Carter on January 17, 1969, by members of the US organization under the influence of the Federal Bureau of Investigation (FBI).

In September 1968, several members of the Southern California chapter of the Black Panther Party enrolled in the high potential program at the University of California–Los Angeles (UCLA). Included in this group were Bunchy Carter, John Huggins and Elaine Brown. It was thought that their presence on the UCLA campus would be an opportunity to recruit Black college students into the Black Panther Party as they helped to build a radical Black student movement. Some of UCLA's Black students, such as Albert Armour and Nathaniel Clark, had already joined the Black Panther Party. Because of Black student activism in San Francisco, UCLA decided to set up a Black studies program. The problem was who was going to be in charge of the program. Ron Karenga, a graduate of UCLA and a member of the community advisory board, had his candidate. The Black students who were represented by the Black Student Union wanted input on who was going to be put in charge of the program and how the program would function. The Black Panther Party supported the students' position.

On January 17, 1969, after a Black Student Union meeting in Campbell Hall on the UCLA campus, members of the US organization shot and killed John Jerome Huggins and Al Prentice "Bunchy" Carter. In May 1969, John Savage, a Black Panther Party member and witness to the UCLA shooting, was shot and killed in San Diego by a member of the US organization. Later, in August 1969, Black Panther Party member Sylvester Bell was shot and killed by US organization members as he was selling the Black Panther newspaper in San Diego. In 1975, during the Church committee

hearings on domestic FBI abuses, the FBI's deadly campaign against the Black Panther Party, known as COINTELPRO, came to light. Part of that campaign involved deliberately inflaming tensions between Ron Karenga's US organization and the Black Panther Party in the hopes of starting a war between the two groups. It became apparent that the Federal Bureau of Investigation had been involved in and admitted responsibility (through memos that gloated about its involvement in the murders) for the assassinations of Al Prentice "Bunchy" Carter and John Jerome Huggins, as well as the assassinations in San Diego of Black Panther Party members John Savage and Sylvester Bell. In 1970, the Southern California chapter of the Black Panther Party opened the Bunchy Carter Free Medical Clinic on Central Avenue in Los Angeles, California. There is a plaque in Campbell Hall on the UCLA campus memorializing the assassination of Deputy Minister of Defense Al Prentice "Bunchy" Carter and Deputy Minister of Information John Jerome Huggins.

Odessa Cox

In the Roaring Twenties, America saw a resurgence of the Ku Klux Klan across the nation. Just a few years earlier, in 1915, D.W. Griffith, a southern sympathizer, sought to rewrite the history of Reconstruction using the newest technology of the day, motion pictures. He produced a silent film called *The Birth of a Nation*. His screenplay was adapted from a novel by Thomas Dixon Jr. called *The Clansman*. It depicted the Ku Klux Klan as glorious saviors of the white race. The movie also gave justification to the black codes and other legislation designed to suppress Black voting, education and labor rights, the precursors to segregation and legalized racial repression. These new laws were designed to suppress the newly won freedom of the Black community at the end of the Civil War and create a second-class citizenship that was enforced by racist intimidation, brutality, beatings, terror, lynching and murder with no legal redress. Under these conditions, living in Alabama for a Black man and his family was dangerous; for a Black union organizer, it made living all but impossible.

On June 8, 1922, Odessa Brown arrived as the newest addition to the Brown family in the small town of Whatley in Clark County, Alabama. Odessa was the second child and the only girl out of three children. Whatley is known for the nearby site of Fort Sinquefield and the so-called Kemble-James massacre

that took place during the War of 1812, which coincided with the Creek Indian war. The town of Whatley is named for Franklin Benjamin Whatley, who built a railroad depot on his land for the Mobile and Birmingham Railroad in 1887. The town soon became a center of transportation for the surrounding farming and cotton-producing communities.

The Brown family was living on an eighty-acre farm that housed other family members. The farm had been homesteaded by Odessa's mother's family, the Burroughs, in the late 1860s and early 1870s under the Homestead Act. The Brown family grew crops to help support themselves. From time to time, just before it was time to harvest the crop, their white neighbor would allow his livestock to destroy the family's crop to show his disdain for his Black neighbors. In an effort to avoid what was sure to be an obvious confrontation, the Brown family moved to Bessemer, Alabama, where Odessa grew up. She remembered her father traveling—as she put it, "hoboing"—to find work during the Depression when there was no work in the local coal mines. There were times when he would work for a contractor for months only to have the contractor skip town when it came time to pay his workers.

Mr. Brown was self-educated, never having attended school. He taught himself how to read and write, having left home at a young age. As a working man struggling to support his family, he saw the need for working people to unite in order to get paid at a fair rate for the work that they were doing. He soon became a staunch union organizer, first for the International Workers Order and then for the CIO (first known as the Committee for Industrial Organizations, but changing its name in 1938 to the Congress for Industrial Organizations) under the leadership of John L. Lewis.

As a Black union organizer in the South, Mr. Brown's life and livelihood were always on the line. He was fired from jobs because of his union organizing. He was away from home most of the time, traveling on union business and speaking to groups of striking workers about the need to organize and unionize in the face of exploitation for a living wage and decent working conditions. This soon brought Mr. Brown (his wife always referred to him as Mr. Brown) under the scrutiny of those self-appointed defenders of white supremacy known as the Ku Klux Klan. Odessa remembered one night as the family was preparing for bed: "I remember we all had on our little sleeping clothes….The door bashed in, and we were wondering. Just before the door bashed in, of course, the door opened real quickly, and we looked—'Daddy!' We said, all of us. He kind of pushed us aside, you know, and said, 'I have to see you.' That's what he told mama, and dashed out the

back door. And by, what seemed like to me three or four minutes after he went through, the door bashed in. And when the door bashed in, it was the Ku Klux Klan in our house....There was about a half dozen of them. We were all scared. My mother was very calm, of course. She just said, 'No, he's not here. I haven't seen him in two weeks.'"

They questioned her and asked, "Where did he go? We know he was in here!" And Mrs. Brown said, "I haven't seen him. I don't know what you're talking about. 'What are you talking about?' Just as if she could be! I think that must've scared me out of 10 years of my growth." Mr. Brown managed to get away, but two weeks later, the family found out that the leader of the local Ku Klux Klan was the very man whom they were buying groceries from and ran the local store. Mr. Brown was away from home for months until things cooled down. The Brown family began patronizing a Black-owned store that was farther away. They only knew the owner as Brother Simmons, and he was able to extend credit to the family as needed.

Odessa went to the local segregated black schools in town that were under-resourced, dilapidated and within sight of the more prosperous white school. Odessa's parents taught her how she should deal with the casual bigotry that was an everyday part of her life. "My mother and father never wanted us to ignore it. They taught us quite early: yes, that's it right there—prejudice or whatever. But you don't let that stop you from what you got to do, you know I got the feeling that it was our duty to correct these wrongs wherever."

After Odessa Brown graduated from the segregated Dunbar High School in Bessemer, Alabama, she met and married Raymond Cox on June 9, 1941. They bought a home in Madison, Alabama, and Ray was working in the local war industry during World War II. Even with Franklin Roosevelt's Executive Order 8802 prohibiting discrimination in the war industries, the bigotry and discrimination on the job in the Alabama war industries was rampant. When Ray received his draft notice, he figured that the army couldn't be any worse than what he was experiencing in his civilian job. When he returned home from the war after fighting against fascism abroad, he found that the exploitation and discrimination at home was even more intense than when he left. Racially, conditions had not gotten better, especially if you were a Black war veteran. At the invitation of an army buddy, Ray and Odessa Cox moved to Los Angeles, California, for a better opportunity and to escape "Jim Crow" segregation.

In February 1944, the Cox family—Ray, Odessa and their daughter, Reba, who was about to turn one year old—arrived in Los Angeles. Odessa fell

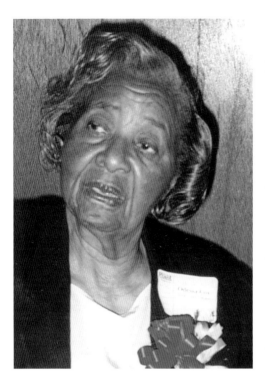

Mrs. Odessa Cox, the unrelenting dynamo behind the establishment of Los Angeles Southwest College. *Courtesy of the Cox family.*

in love with Los Angeles, but the specter of racism was ever present. On the first day that they arrived in Los Angeles, Ray was denied a cup of coffee at the Biltmore Hotel coffee shop, where he was told, "We don't serve your kind here." In another instance, when they were out for a Sunday drive, their youngest child wanted a glass of water. When they stopped at a little café, they were told to get water from a hose at the filling station next door. Ray and Odessa knew the rules in the "Jim Crow" South, but in Los Angeles, they were introduced to something new and more subtle, "James Crowe Esquire," where the rules were arbitrary and at times confusing. With the war still on, Ray was able to find work making a living wage with the longshoremen. He soon became active in the union. After moving in with a friend who lived in the Watts section of Los Angeles, the family soon moved into the Jordan Downs housing project. With the war winding down, there was soon talk of layoffs on the docks, and since most of the Black longshoremen had only come on recently, it was last hired, first fired.

Mr. Cox was no fool, and seeing the writing on the wall, both he and his wife took classes at the local junior college (which was far from local) to learn the trade of dry cleaning. They were turned down for a small business administration loan by Mr. Myers, the local head of the Small Business Administration, with the explanation that if they were given the loan they would be out of business within a year (Utopia Cleaners remained a family-owned business for forty-eight years). So, they financed their business themselves with the money that Mr. Cox made as a longshoreman. In June 1945, Mr. and Mrs. Cox opened Utopia Cleaners at 1820 East Ninety-

Seventh Street. In fits and starts and with grit and determination, Mr. and Mrs. Cox made a success out of their business while raising their three daughters, Reba, Sandra and Brenda.

The business was a family affair, and the girls proved just as entrepreneurial as their parents. With the help of their Uncle Lilton (Odessa's oldest brother), the girls learned how to save their money. Their dry cleaning business and their home was in the same building, with the business in the front and a home in the back. The girls' school was close by, and Mrs. Cox was always available to run down to the school and talk to the teachers in the middle of the day or go to the PTA meetings. Mrs. Cox made sure that her daughters were exposed to dance, music lessons and day camp. According to Sandra, "Raymond and Odessa Cox were teaching their daughters to become self-sufficient, educated and knowledgeable about their total environment: politically, socially, economically, or otherwise.…[W]e believe that Blackness is not the hue of your complexion, but the state of your mind." Raymond and Odessa Cox knew the importance of a solid education and made sure that their daughters would receive what had been denied them in the "Jim Crow" South.

Mrs. Cox's oldest daughter, Reba, excelled in school, but being one of the few Black students, she was often ostracized. In a quest for a better education for her daughter, Mrs. Cox demanded and got a transfer that allowed her daughter to go to Gage Avenue Junior High School in Huntington Park instead of Jordan High School in Watts. Later, when the family moved west, Reba found herself as one of the few Black students at George Washington High School. Reba and the other Black students were ostracized and often harassed by members of the racist white gang known as the "Spook Hunters." There were teachers and administrators who displayed a blatantly bigoted attitude toward the Black students.

In 1956, in many of the school textbooks, if Black people were mentioned at all, it was in a negative or derogatory way. Mrs. Odessa Cox worked together with other parents and the PTA to change the curriculum and the textbooks to give a truer image of Black people in history, literature and the arts. She also organized a committee of concerned citizens that pushed to alleviate the overcrowding at Bret Hart Junior High School by getting the school district to build a new junior high school in the area. The fruit of their efforts became known as Henry Clay Junior High School. Of course, Henry Clay was just a precursor to her true mission: organizing what would become Los Angeles Southwest Junior College.

As Mrs. Cox noted, "Well, one of the reasons why I demanded that we put Southwest College out here is because, all these years they talked

about the ghetto and how no education, and blah blah blah. Well, I said put education closer so people can go! Because oftentimes, these people don't have enough money to pay to go to city college. You have to have a car to go to [Los Angeles] City College. My daughter went to city college. You take what—two to three streetcars. You could imagine what time of day she had to get up to get there."

Mrs. Odessa Cox began her campaign to establish Southwest Junior College in 1950. Her campaign was ultimately successful with the opening of Southwest Junior College in 1967. She faced many obstacles along the way. Despite their promises to build a junior college adjacent to the Black community, the school board decided to build Harbor College before it built Southwest College. The school board said that there was a greater need for a junior college in the harbor area. Of course, after Harbor College was built they had a problem attracting students. Mrs. Cox would not be deterred. She organized her community and demanded a quality postsecondary educational facility in her community. She got a boost when her group saw the need to work with the campaign against Proposition 14, a California proposition meant to overturn the Fair Housing Act in California. This racist

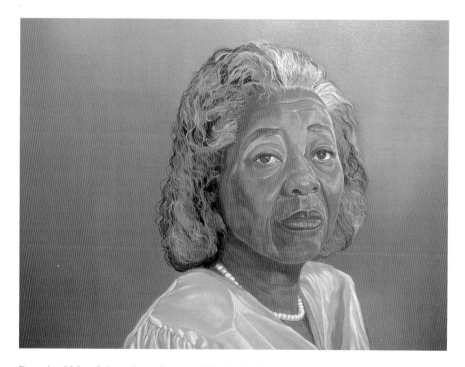

Portrait of Mrs. Odessa Cox. *Courtesy of the Cox family.*

piece of legislation was supported by a former actor turned politician who was running for governor named Ronald Reagan. The proposition passed, to the disappointment of many in the Black community, but it was later overturned by the United States Supreme Court.

In August 1965, Mrs. Cox saw her community burn and then become occupied by the military for several weeks. The Watts rebellion had blown the lid off the inequality and discrimination that Black and other people of color had suffered under for years. In an effort to pacify the community, the school board moved the college from the back burner. After the funds were allocated to build Southwest College, the fight was now over curriculum. The school board wanted Southwest College to be a technical school. Mrs. Cox and her group of concerned citizens wanted an academic institution in their community and fought for that to become a reality. After fighting for twenty-seven years, Mrs. Odessa Cox was able to bring to her community a local junior college at the corner of Western Boulevard and Imperial Highway. Mrs. Cox's daughter Sandra tried to explain her mother's passion: "My maternal grandfather fought for human and civil rights in the 'Heart of Dixie' in the 1920s and '30s. And when he died, he passed the torch onto my mother....For to live life and not to have improved it in some way, would be a wasted life in her opinion." When asked if she was bitter, Mrs. Cox said, "Yes, I admit I'm bitter there. I feel like I have been denied an awful lot in my life. Worst of all is not having an education that I should've had....I feel like yes, I've been denied this, that, and other things—these rights and so forth. But get out there and do something about it. This has been my attitude all my life, you know. Don't just sit there and talk about it. Get up and do something about it."

Mrs. Odessa Cox passed away on October 27, 2001. She received many accolades and awards over the years, but probably the most meaningful award is the building on the campus of Southwest College that is named in her honor.

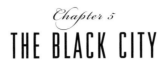

THE BLACK CITY

The members of the Black generation who came after World War II were no longer willing to passively accept the racial restrictions that American society had imposed on them. Soldiers who had fought in segregated units against fascism and imperialism in other lands would no longer tolerate the same at home. In 1948, the Supreme Court ruled that restrictive covenants could not be enforced. This ruling opened up housing to Black families that had been racially restricted.

The city of Compton found itself in the crosshairs of the fair housing battle. In the 1950s, Compton was virtually an all-white bedroom community with a growing Black community on its northern border. In September 1946, the Black community known as George Washington Carver Manor sold 110 new homes to Black middle-class homeowners and veterans of World War II on the first day. By 1949, three hundred Black families lived on Compton's northern border at El Segundo and Central Avenue. The reaction of the white residents in the city of Compton was fear, and they became very hostile to the burgeoning Black community. By the 1960s, the most egregious examples of "blockbusting" were taking place in the city of Compton. This cynical real estate scheme lined the pockets of real estate brokers and predatory lending bankers while destroying any hope for a stable, integrated community. Instead, the Black families who moved into the city of Compton were met with racial hostility, at times overt and at other times very subtle.

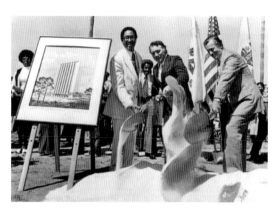

Dr. Ross Miller was a former president of the Compton School Board and a member of the Compton City Council. He fought for fair representation of the Black community in the city of Compton. In this image, he is participating in the groundbreaking for the new $27 million Compton Courthouse on August 30, 1974. *From left to right*: Dr. Ross M. Miller Jr., Supervisor James A. Hayes and Alfred J. Courtney, presiding judge of the Los Angeles County Superior Court. Dr. Miller was the chief of staff at Dominguez Valley Hospital in Compton, and he also served as the first Black president of the Los Angeles Surgical Society, past president of the Medical Dental and Pharmaceutical Association of Southern California and past president of the Southern California chapter of the American College of Surgeons. He was also chairman of the board of the Charles Drew University of Medicine & Science.

In 1964, Dr. Ross M. Miller, a well-respected surgeon, wanted to build his medical practice in Compton. His family found a house for sale on Atlantic Drive on the east side of Compton, close to his job as chief of staff of Dominguez Valley Hospital. Once he inquired about the home for sale to the white homeowner, he found that the homeowner did not want to sell to a Black man. Dr. Miller was forced to have a white friend purchase the home that he wanted and quick-claim the home to him. Having to go through this subterfuge in order to buy a home outraged the good doctor. Once he settled into his home, he became involved in local politics. He was elected to the school board and soon became president of the board, where he dealt with instances of racial insensitivity in the curriculum, discrimination and maltreatment of Black students within the school district.

Dr. Miller's politics led him in 1968 to support the candidacy of Senator Robert F. Kennedy. He was there that night in June when the senator was shot in a ballroom at the Ambassador Hotel in Los Angeles. When the call went out for a doctor, he did not hesitate, but he was stopped by several people who did not believe that this Black man was actually a doctor. He was the first to apply first aid to several of the gunshot victims, including the senator. Unfortunately, Senator Kennedy passed away from his injuries the next day, while the other gunshot victims eventually recovered. Dr. Ross Miller was elected to the Compton City Council in a sweep that brought in not only the city's first Black mayor but also a majority Black city council. In 1969,

America did not think that a Black man could quarterback an NFL football team let alone run a city. With a majority Black school board, city council and the first Black "elected" mayor west of the Mississippi, the spotlight—or, should I say, the microscope—was on the city of Compton, ready to highlight anything negative in the city to support the white supremacist narrative. Compton became notorious as the "Black city." Neighboring cities changed the name of the major thoroughfare that ran east–west through the county because it was called "Compton Boulevard." To the east, it became Somerset, and to the west, it became Marine Avenue. Compton and its Black residents became the victims of negative urban mythology. Even though most of its elected officials were college educated or held advanced degrees, they were labeled as corrupt buffoons by the mass media in an effort to paint a picture of a city run by incompetent crooks. And this was before Ronald Reagan's foreign policy in South America led to the crack epidemic that all but decimated the city of Compton in a low-level guerrilla war between competing drug gangs.

DOUGLAS F. DOLLARHIDE

Douglas F. Dollarhide was born in Earlsboro, Oklahoma, on March 11, 1923, to Daisy and Thomas Dollarhide, a former slave. Douglas was the youngest of twelve children. His mother passed away when he was three years old, and his father passed away ten years later. He was raised by an older brother and sister in Oklahoma. At the age of seventeen, he came west to San Jose, California, to live with his brother Emmett, who was a leading civil rights activist in the Bay Area and became an inspiration for his own civil rights work later in life. Dollarhide was inducted into the United States Army during World War II. He fought in the European theater with a racially segregated transportation unit, the "Rolling Hellcats."

During the Allied breakout from the coast after D-Day, the United States Army developed a truck convoy program to bring much-needed military equipment and supplies to the front. This was called the "Red Ball Express," and about 75 percent of the drivers were Black. The 1952 World War II film *Red Ball Express*, starring Jeff Chandler and featuring a young Sidney Poitier, was heavily criticized for minimizing the participation of Black soldiers. The film's director, Budd Boetticher, is said to have claimed, "The United States Army wouldn't let us tell the truth about the Black troops because the

Douglas F. Dollarhide became the first Black person elected mayor of a major municipality west of the Mississippi when he was elected mayor of the city of Compton in 1969. *Yvonne Day Family Collection, courtesy of the Compton 125 Historical Society.*

government figured they were expendable. Our government didn't want to admit that they were kamikaze pilots. They figured if one out of 10 trucks got through, they'd save Patton and his tanks." Dollarhide saw action in battles in Normandy, northern France; Ardennes, Rhineland; and central Europe under the command of General George S Patton.

Like many veterans of World War II, Douglas Dollarhide; his wife, Eliza (aka Ruby), whom he married in 1943; and their daughter, Barbara, found a home and opportunity in Los Angeles, California. Mrs. Dollarhide, who

was described by her husband as "the girl that God sent me," became a cosmetologist, the owner of two beauty shops and an instructor at Los Angeles Trade Tech College, while her husband worked as an employee of the United States Postal Service and later as a sales manager for the local Compton Dodge dealership. He continued his college education, eventually receiving his law degree from LaSalle University Law School.

After moving to the city of Compton in the late 1950s, Douglas Dollarhide became active in the local National Association for the Advancement of Colored People (NAACP). During this time, many Compton residents, businesses and institutions were hostile to the burgeoning Black presence in the city. Dollarhide would become president of the Compton NAACP, where he worked with other NAACP activists, most notably the legendary Maxcy Filer. Filer would become his friend and campaign manager in his 1963 election to the Compton City Council, making him the first Black person to hold that position in the city's history. As a member of the city council, he became chairman of the finance committee and represented the City of Compton at the League of California Cities. He was also a member of the Los Angeles County Library Advisory Board, where he oversaw the building of a county library in the new $15 million Compton Civic Center, which would include a county courthouse and the new Compton City Hall.

While a city councilman, Douglas Dollarhide saw great changes in the nation and the state of California that directly affected the city of Compton. The Supreme Court had ruled in 1948 that racial housing covenants were not enforceable. Then, in 1963, the Rumford Fair Housing Act (a bill that was sponsored by Assemblyman William Byron Rumford, the first Black man elected to the California State Assembly from Northern California) was passed by the California legislature, making it illegal to deny housing on the basis of ethnicity, religion, sex, marital status, physical handicap or familial status. In 1964, the California Real Estate Association sponsored an initiative to challenge the Rumford Fair Housing Act. This challenge was called Proposition 14 and was supported by right-wing conservative groups and individuals like the California Republican Assembly, the John Birch Society and that amiable actor turned politician Ronald Reagan, who stated, "If an individual wants to discriminate against Negroes or others in selling or renting his home, he has a right to do so." This discriminatory initiative proved to be extremely popular in the segregated white communities of California, which included parts of the city of Compton, and was passed by 65 percent of the California voters in 1964. With the support of the sitting governor, Pat Brown, the constitutionality of Proposition 14 was challenged

and struck down by the United States Supreme Court. Unfortunately for Governor Pat Brown, his stance for fair housing was unpopular in California, and he was defeated in his bid for reelection by Ronald Reagan, who had supported Proposition 14.

The fight for fair housing saw the beginnings of white flight in the city of Compton, but the 1965 Watts rebellion intensified the phenomenon into a "white panic." In the early 1960s, because of the use of racist real estate tactics such as "blockbusting," whole neighborhoods on the west side of Compton were changing from majority white to majority Black in a matter of months. The use of stereotypes and fear of the coming "Negroes" brought huge profits to the real estate agents, brokers and banks, who participated in this activity and destroyed any hope of a stable, integrated community. Because most of the white merchants in the city of Compton lived in the city, white flight led to the loss of many small businesses. Compton's small downtown district was devastated, as was the tax base that those businesses provided. The loss of the city's tax base would soon affect the city schools and other institutions.

In 1969, Douglas F. Dollarhide became the first Black man to be elected mayor of a major municipality west of the Mississippi when he was elected

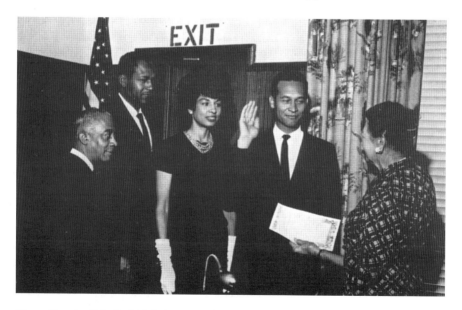

Mayor Douglas F. Dollarhide being sworn in. Looking on is his wife, Ruby, Los Angeles city councilmen Thomas "Tom" Bradley and Gilbert "Gil" Lindsay. (Gil Lindsay was the first Black man appointed to Los Angeles City Council in the twentieth century, and Tom Bradley was the first elected Black city councilman in the twentieth century.) *Cal State Dominguez Hills.*

mayor of the city of Compton. Even though a majority of the voting citizens of Compton elected Mayor Dollarhide, the city was divided along racial lines. East Compton was, for the most part, a racially restricted white community. West Compton was mostly Black and contained a historically Chicano community in the vicinity of Sacred Heart Catholic Church on the northwest side. Even though the Black community made strides in getting representation on the city council, most of the departments, civic organizations and institutions remained dominated by the white community.

In an effort to address the deteriorating tax base, Mayor Dollarhide proposed that the city of Compton should annex the unincorporated areas that bordered the city that were zoned for light manufacturing. These efforts were rebuffed by the all-white county commission that oversaw the annexation of unincorporated areas. With an eroding tax base, the loss of homeowners due to predatory lending, under-resourced schools and a loss of after-school activities, juvenile crime and violence became a huge political issue in the city of Compton. One of the remaining white-dominated institutions in the city of Compton was the Compton Police Officers Association (CPOA). According to the former head of the CPOA, John Baker, the association became politicized and opposed the new mayor and his policies, especially the appointment of Thomas "Tom" Cochée to lead the Compton Police Department, making him the first Black police chief in the state of California.

According to John Baker in his book *Vice*, in a clandestine and possibly illegal effort to unseat the mayor of Compton, the police officers' association approached a member of the white business community who was opposed to Mayor Dollarhide. Vito Pasquale was the owner of a topless bar called the Golden Garter on Long Beach Boulevard, just south of Rosecrans Boulevard. According to Baker, this was the de facto headquarters of the Compton Police Officers' Association. In his book, Baker described how the association planned to unseat Mayor Dollarhide:

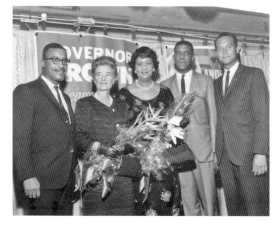

From left to right: California assemblyman Leon Ralph, Mrs. Brown (wife of Governor Edmund G. "Pat" Brown), Dorothy Height, Bill Green and Douglas Dollarhide. *Cal State Dominguez Hills.*

In keeping with long-standing tradition, CPOA meetings were usually held at the Golden Garter over pitchers of beer and under the smoky gazes of the strippers. Vito Pasquale often sat in on these meetings, and one night, while we were discussing how to proceed with Dollarhide, Vito offered his opinion that only money could beat him. "We can't contribute to a political campaign," I answered. "It's against the law." "Maybe you can't," Vito said, "but I can." I asked him what he meant. "We gotta get rid of this son of a bitch. You can find somebody you want to run against Dollarhide, and I'll bankroll the campaign." I asked Vito if he had that kind of money. "Me…and some other businessmen who want Dollarhide out," he answered. "You just find us a candidate with balls." I knew who we wanted. Doris Davis, the city clerk, has supported us through the blue flu and consistently beyond….As a woman and a black, she would be a credible candidate against Dollarhide. Vito agreed, and he gave me an envelope containing $2500 in cash. "If she goes for it, give this to her," he said. "Tell her it's just the start. The one thing I ask: if she gets in, they'll be no more topless licenses granted in Compton."

As Mayor Dollarhide ran for reelection, his campaign was consistently outspent by his opponent, Doris Davis. In an effort to draw a contrast between the light-skinned Douglas Dollarhide and the dark-skinned Doris Davis, a cynical ploy reminiscent of the "Willie Lynch Letter" was injected into the campaign, according to John Baker. Roland Ballard, a Compton police officer and member of the Compton Police Officers' Association, found a photo of Mayor Dollarhide in Florida smiling broadly between two blondes, who were smiling adoringly. In an effort to destroy the mayor's reputation, Ballard, acting as an operative for the CPOA, featured the photograph in a political hit piece with the caption, "He can pass for white when he wants to." Even though the mayor had worked tirelessly to increase the city's tax base by luring businesses back to the city, built a new civic center and county courthouse and had brought in a progressive Black police chief to deal with the rising juvenile crime rate, Mayor Dollarhide lost the election to Doris Davis, who became the first Black female mayor of a major municipality west of the Mississippi. In order to supply her with a conservative majority on the city council, the CPOA supported Hilliard Hamm and Russell Woolfolk for the city council. Hamm and Woolfolk would later be indicted for corruption in a real estate kickback scheme.

Former California lieutenant governor, congressman, state senator, assemblyman and legendary Black politician Dr. Mervyn Dymally

described Douglas Dollarhide as "a cultured man and most effective as the Mayor of Compton." Douglas Dollarhide passed away on June 28, 2008, at the age of eighty-five. The Compton mayor at the time of Mayor Dollarhide's passing, Eric Perrodin, noted, "All the people in the city of Compton will mourn the passing of Mayor Douglas Dollarhide; he was the first Black Mayor of the city of Compton. If it weren't for him many elected officials such as myself would not be sitting in the seats we are sitting in now." As Compton strives to reach its potential in the twenty-first century as a multiethnic, multicultural city, many citizens remembered the leadership of Douglas F. Dollarhide with the opening of the multimillion-dollar Douglas F. Dollarhide Community Center on May 31, 2014.

THOMAS "TOM" COCHÉE

The relationship between the Black community and law enforcement in our country is unique and complex. Much like any other community, the Black community needs to have a positive relationship with its local police force in order to provide a stable, safe environment. Unfortunately, the history of the Black community and the police forces of this country as they are currently structured has not been able to provide that positive relationship. This lack of a positive relationship has had disastrous results, which have only been repeated over time.

America has been sold on the Hollywood-created myth through shows such as *Dragnet* and *Adam 12* that the local police departments enforce laws equally in all communities under the directive "to protect and to serve." Unfortunately,

Compton police chief Thomas "Tom" Cochée was the first Black police chief for a major municipality in California. His innovative policing style reduced crime and was the forerunner of modern community policing. *Courtesy of the Cochée family.*

the reality has always been quite different when it came to enforcing laws in the Black community. Historically, the directive for policing in the Black community has always been "to suppress and contain," with an emphasis on protecting property over people. To understand the difference in the policing of the Black community, you have to go back to the origins of law enforcement of the Black community in this country.

In the United States of America, policing of the Black community began with the "slave patrols" of the 1700s as a way of controlling the movement and behavior of the enslaved population, often with brutal results. After the Civil War, the slave patrols were incorporated into the local police forces and the Ku Klux Klan, which in many places were one and the same. In an effort to contain the aspirations of the Black community, extrajudicial efforts such as lynchings, beatings, public whippings and punitive arrests were enforced by local police agencies in conjunction with the Ku Klux Klan and other white supremacist organizations.

After Reconstruction and the development of Black townships and communities, the threat of racial violence by the local white community with the support of the local police department was ever present. At the end of World War I, this threat became a reality to Black communities across the nation in what was called the "Bloody Summer of 1919." White mobs with the support of local law enforcement attacked and killed Black people on the streets and burned their homes and businesses. These atrocities led to the formation of the African Blood Brotherhood, a Black socialist, armed self-defense organization founded by Cyril Briggs in Harlem, New York, with chapters in Black communities throughout the United States, including the Greenwood section of Tulsa, Oklahoma, where in 1921 mobs of white terrorists, with the support of the local police department and later the National Guard, burned down the Black community and massacred many of its residents, including women and children. In many Black communities across the United States, the local police departments acted much like the old slave patrols had in the past, with their mandate to enforce "Jim Crow" segregation laws. The protection of property was paramount, and the mission of "suppress and contain" was ever present. The Fourteenth Amendment of the Constitution and the idea of "equal protection under the laws" sounded like a cruel joke.

On June 25, 1941, President Franklin Delano Roosevelt signed Executive Order 8802, which outlawed racial discrimination in the defense industry. President Roosevelt signed the order to avoid the threat of a Black-led

march on Washington, D.C. A. Philip Randolph and NAACP executive secretary Walter White had successfully lobbied the president of the United States. Within months, the United States would enter World War II with the attack on Pearl Harbor on December 7, 1941. The president's executive order outlawing discrimination in the defense industry and the start of World War II led to a mass migration out of the South to the West Coast defense industries. Many West Coast Black communities had been contained to small areas of the city by housing discrimination, redlining and racial covenants. As the Black population grew, many of these communities became overcrowded with substandard housing and no way to expand without encroaching on white neighborhoods. This situation only became more acute with the return of the soldiers, sailors and marines who had fought in segregated units during World War II only to face discrimination and racism at home. These returning veterans who had fought against Nazi fascism and Japanese imperialism could no longer accept the status quo of segregation, discrimination and racism at home.

Men like Reverend Vernon Johns, Reverend Martin Luther King Jr., Reverend Fred Shuttlesworth, Bayard Rustin and Paul Robeson and women like Daisy Bates, Rosa Parks, Fannie Lou Hamer, Dorothy Height and Coretta Scott King, along with many others, organized and led boycotts and demonstrations against segregation and racism. These actions were violently opposed and suppressed by openly racist local police departments, with the best example being Police Commissioner Theophilus Eugene "Bull" Connor of Birmingham, Alabama, who unleashed high-powered fire hoses and police attack dogs on men, women and children who had the nerve to protest for equal rights in the United States of America. Most Americans watched this gruesome nightmare of police brutality and racism virtually every night on the television news. To many white Americans, this looked like something that was happening in a foreign country. Black Americans in the South and the North knew it as reality. Police brutality and murder in northern cities was ignored, for the most part, by the majority population as long as the Black ghettos remained contained and quiet. The white population was happy with race relations as long as the Black population was "out of sight, out of mind."

In August 1965, the festering poverty, lack of services, substandard housing and the brutal policing tactics of the Los Angeles Police Department would cause the Watts section of Los Angeles, California, to no longer be "out of sight or out of mind," as it exploded and raged from August 11 to August 17,

1965. The city of Los Angeles realized that it had its own version of "Bull" Connor in Los Angeles police chief William H. Parker.

In August 1965, Sergeant Thomas "Tom" Cochée, one of a very few Black law enforcement officers, was working the community relations detail in Watts for the Los Angeles Sheriff's Department. What he witnessed before and after the Watts rebellion convinced him that the current policing techniques could not be sustained. He became an advocate for new and innovative approaches to policing in the Black community.

Born in New York City on January 7, 1932, Tom Jones was adopted by his stepfather, Charles Cochée, who, according to his daughter Tricia, showed him a "strong work ethic and what it meant to take care of family first." When Tom Cochée was nine years old, he moved to California with his mother and stepfather—first to Los Angeles, where Tom would attend Foshay Junior High School, and then to the community of Monrovia, California, where he would attend Monrovia High School. Tom's daughters, Renée and Tricia, remember their father as "always a good athlete as well as a good student, he was on the track team and had a lifelong interest and participation in track events as well as weightlifting, tennis and swimming."

Tom Cochée married at sixteen and dropped out of school to start working. According to his daughters, he learned the maintenance business and soon opened his own janitorial service. Tom was ambitious and wanted to take care of his growing family. He soon went back to high school and earned his diploma. After high school, he applied for and was hired by the Los Angeles County Sheriff's Department, where he worked for the next twelve years, attaining the rank of sergeant. During his time at the Sheriff's Department, he made friends with other Black deputies, who happened to be from New York. They formed a social club called the "New Yorkers." Tom's daughters Renée and Tricia recalled "the dance parties at the Cochées' as legendary, with all the 'New Yorkers' in attendance dancing the latest dances and seeing who could dance the best." They also remember the social gatherings held by the New Yorkers at Val Verde Park. (Also known as the "Black Palm Springs," it was a Black resort in the Santa Clarita Valley.) While working at the Sheriff's Department, Deputy Cochée continued his education, attending Southwestern University School of Law and receiving his Bachelor of Science degree in police science and administration from California State University–Los Angeles and soon earning his master's degree in public administration from the University of California–Berkeley. After twelve years with the Sheriff's Department, Sergeant Cochée would become an investigator for the Los Angeles County Public Defender's

Office for the next four years before being offered the position of head of the Criminal Justice Department at Merritt College in Oakland, California, where he would hone his philosophy of innovative community policing. Just a few years earlier, the Black community in Oakland had formed a self-defense organization that would become internationally known for its bold stance against exploitation, racism and the brutal police tactics that are common in the Black community.

The Black Panther Party was formed by Bobby Seale and Huey Newton on October 15, 1966, in response to the brutal police tactics and racist attitudes that were common in the Oakland Police Department. The organization began armed community patrols of the police. Squads of legally armed members of the Black Panther Party would observe police interactions with the community to ensure fair and equal treatment. The patrols were so successful that the State of California proposed and passed legislation that would outlaw the carrying of loaded firearms, making the community patrols of the police illegal. According to Tom Cochée's daughter Tricia, "Understanding the Panthers' concerns around community policing and police abuse, Cochée was an 'unofficial' resource for legal ethics." As reported by Tricia, family members remember Bobby Seale as a guest in their home. "It was not long before many community members in Oakland and throughout the Bay Area came to Prof. Cochée and said he would make a good Sheriff for Alameda County and that he should consider running for that political office." After much deliberation, Tom Cochée decided to run for sheriff of Alameda County. At about the same time, the first Black mayor of a major municipality west of the Mississippi was looking for a new police chief.

Mayor Douglas F. Dollarhide was the first Black mayor of the city of Compton, California. Located south of Watts, Compton had seen a massive demographic shift over the ten years before Mayor Dollarhide's election in 1969. The effects of "blockbusting" and predatory lending adversely affected the housing market in the city of Compton, effectively replacing homeowners with renters. White flight had also adversely affected the Compton business community. The white owners of small businesses that had been the hallmark of the city's economy relocated their businesses to other communities as they fled the city of Compton, leaving the once bustling downtown a virtual ghost town of closed shops and businesses. With diminished property and sales taxes, the city was no longer able to adequately fund its highly touted school system and community youth programs. Mayor Dollarhide's efforts to annex manufacturing areas that bordered the city of Compton to the east

and to the west in an effort to sustain an eroding tax base were rebuffed by the county commission. Mayor Dollarhide found himself under a spotlight; there were many who were looking for him to fail so that they could remain comfortable in their racist stereotypes. Even though he was elected mayor, Dollarhide found his administration being opposed by many of the white department heads in the city government. This included the Compton Police Officers' Association, which was quick to point out the rising crime rate in the city of Compton and blamed the mayor and his administration.

Near the end of Dollarhide's term as mayor, longtime Compton police chief William Ingram was due to retire after twenty years of service. This gave Mayor Dollarhide the chance to appoint a progressive Black chief of police who could bring down the crime rate in the city without being brutally suppressive. Mayor Dollarhide chose Professor Thomas W. Cochée because of his experience and his innovative ideas on policing a Black community. On July 1, 1973, Cochée became the first Black police chief of the city of Compton, making him the first Black police chief in the state of California. It was only fifteen years earlier that the city of Compton had hired its first Black police officer, Arthur Taylor, in 1958.

Chief Cochée was quoted as saying, "There are policemen in this department and other departments around the country who think you prevent crime by beating people up. I don't believe you change human behavior for the better by being physically abusive of people." As police chief, Cochée would change the shooting policy of the Compton Police Department. He insisted that his police officers only use their weapons to protect themselves or another human life, never firing at a fleeing suspect who did not pose an immediate danger. The chief would no longer allow two white police officers to man a patrol car. Because of the racial makeup of the city, he believed that it made more sense to have a white officer ride with a Black or Hispanic officer as a way of being more sensitive to the community. One of his most controversial initiatives was to make it mandatory that Compton city police officers live in the city of Compton, just as he did.

The chief supported crime prevention programs and was known to aggressively confront crime in the community. The chief spent time analyzing crime statistics and understanding the economic and social conditions that led to criminal activity. He would come to focus on juveniles, who, according to his observations, were the largest contributors to his crime statistics. Lack of jobs, numerous vacant houses and lack of organized community activities led to increased gang activity and delinquent behavior. When it came to the racial myths about crime in the city of Compton, the chief was quoted as

saying, "What is happening in Compton happens in any community that has a low social economic status, it happens not only in Black communities or in Brown communities but in poor white communities too." Because of Chief Cochée's progressive community policing philosophy, members of the Compton Police Officers' Association who were uncomfortable with his leadership actively plotted to undermine his administration. Chief Cochée observed that "there are some white officers who have chosen not to speak to me, but then one doesn't run a Police Department on friendship." Most importantly, crime statistics under Chief Cochée's leadership were down or leveling off—significantly, the city's murder rate was down by 50 percent.

Chief Cochée asked the Compton City Council to help him build on this success by hiring civilian youth workers and more police officers. His requests were rebuffed. It seemed that there were some differences between the chief and members of the city council. Councilman Hillard Hamm and Councilman Russell Woolfolk charged the chief with insubordination and asked the city manager, Daniel Lim, to fire him. Chief Cochée was fired but fought back and was able to regain his job within a month after rallying public support and proposing a public airing of the charges against him. Both of the city councilmen who unsuccessfully forced his firing, Woolfolk and Hamm, were later sentenced to federal prison, convicted of extortion involving a community redevelopment program.

Compton police chief Thomas W. Cochée stepped down from his post on August 30, 1976. He became chair of the Department of Administration of Justice and Police Science at Moorpark Community College, where he taught for sixteen years. He also owned a maintenance and security business that allowed him to hire youth he saw potential in and who needed a job. In 1991, Thomas "Tom" Cochée, the first Black police chief of a major municipality west of the Mississippi, died of cancer.

MAXCY D. FILER

Born in the Depression-era "Jim Crow" South to hardworking parents, Maxcy Dean Filer arrived in the small town of Marianna, Arkansas, on May 29, 1930. Maxcy's father, Squire Filer, worked as a railway baggage handler, and his mother, Vera Filer, taught school. Maxcy was the youngest of five siblings and the only boy. In 1946, Maxcy joined the United States Navy. When his hitch was up, like millions of other veterans, he went to college, with prospects of becoming

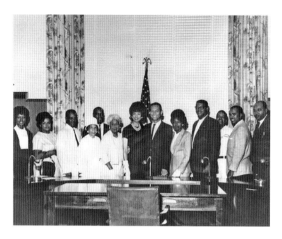

Newly installed Compton mayor Douglas F. Dollarhide (*center*) with staff and supporters. Second to the left of Mayor Dollarhide is the legendary Compton civil rights icon Maxcy Filer, who was a friend and confidant of the late Dr. Martin Luther King Jr. *Cal State Dominguez Hills.*

a dentist. First attending the University of Arkansas–Pine Bluff, he eventually moved to Indiana to attend the Elkhart Business University, where he studied to become a dental technician. While at Elkhart, Maxcy met and fell in love with Blondell Burson, and the two were soon married. In 1952, Maxcy graduated from Elkhart, and the newlyweds moved west and eventually settled in Compton, California.

In the 1950s, the city of Compton was over 95 percent white, with a substantial Mormon population. Needless to say, not everyone was happy when the Filers moved into the neighborhood. Some neighbors refused to speak to them, but those who did found a smiling face and an outstretched hand in Maxcy Filer. Even though Maxcy could be an imposing figure, standing more than six-foot-three with a firm handshake and a pleasant disposition, he had no tolerance for bigotry or injustice. Maxcy strived to become the embodiment of the involved citizen. His son, Superior Court judge Kelvin Filer, described his father, "He strongly believed in justice.… He saw that the legal arena was the way that things were getting done."

Maxcy Filer's views on using the courts to advance equality fell in line with the philosophy of the National Association for the Advancement of Colored People (NAACP), and he soon became president of the Compton branch. He organized picket lines against banks and other businesses that would not hire Black employees, and he exposed housing discrimination and racist real estate practices. Under Maxcy's leadership, the Compton branch of the NAACP organized voter registration drives and provided legal help for people who had been discriminated against. In 1963, Maxcy Filer was a leader of the Southern California NAACP delegation to the March on Washington and a confidant of Dr. Martin Luther King Jr. That same year, he worked as the campaign manager for Douglas Dollarhide as he became the first Black city councilman in the history of Compton. After the 1965

Watts rebellion, Maxcy testified before the McCone Commission, pointing out the causes of the rebellion and what needed to be done to eliminate the inequities in the community. In 1966, he graduated from Van Norman Law School and studied to pass the bar exam. He passed the bar in 1991 after forty-eight attempts. Maxcy Filer was sworn in on June 6, 1991. Robert M. Talcott, in his address to the new members of the bar, pointed out the characteristics of a successful lawyer: "Three of these characteristics are personified by Maxcy Filer, persistence, persistence, and persistence."

In 1969, Maxcy Filer was instrumental in the campaign of Compton's first Black mayor, Douglas Dollarhide. With Maxcy's help, Douglas Dollarhide became the first Black mayor of a major municipality west of the Mississippi. Maxcy was also a mentor to Los Angeles Superior Court judge Michael Kellogg, who said of him, "Maxcy was a friend and mentor who was dedicated to improving the quality of life for all people." Legendary California politician and former lieutenant governor Dr. Mervyn M. Dymally credited Maxcy Filer with urging him to run for Congress. In the mid-1970s, Maxcy successfully ran for a seat on the Compton City Council, where he served for fifteen years. In the 1980s, as a result of President Ronald Reagan's foreign policy in South America, the city of Compton, like many other communities in Southern California, found itself in the grip of a cocaine epidemic. The cocaine-fueled guerrilla war that was taking place on the streets of Compton was reflected in the increase in the homicide rate. Semiautomatic and automatic gunfire tore into the flesh and destroyed the lives of innocent and guilty alike. Compton city councilman Maxcy Filer pursued a controversial city ordinance that would ban semiautomatic rifles, and this brought him political pushback and criticism from the National Rifle Association. Councilman Filer stood tall against the criticism and opposition because he believed it was the right thing to do.

Maxcy Filer could often be seen walking the streets of his district, getting to know his constituents. With a ready smile and a strong handshake, he cemented many friendships that have only grown throughout the years, earning him the nickname "Mr. Compton." His activism and reputation in the community was an inspiration that spawned the television sitcom *Sparks*. Maxcy's love for the law inspired many, most importantly two of his sons who both became lawyers, Kelvin and Anthony. Kelvin is now a highly respected Superior Court judge working out of the Compton Courthouse.

Maxcy Dean Filer passed away on January 10, 2011. He touched the lives of many and left a whole community to mourn the loss of a truly inspirational man. He proved that one man could make a difference.

KEEPERS OF THE FLAME

Delilah Beasley

Just two years after the end of the devastating War Between the States, Delilah L. Beasley was born on September 9, 1867, in Cincinnati, Ohio. She was the eldest of five siblings. Delilah started writing short stories as a teenager. Soon she was published in local newspapers. The untimely death of her parents when she was a young woman forced her to find various types of employment, from personal maid to massage therapist. In 1910, Delilah moved to Oakland, California, where she wrote columns for local newspapers, including the *Oakland Sunshine* and the *Oakland Tribune*. She also attended lectures at the University of California–Berkeley, where she learned how to archive and research historical material.

Delilah researched and wrote several groundbreaking books about the Black experience in California. Her first book, written in 1918, *Slavery in California*, gave written proof of the existence of Black pioneers in California. Her 1919 book *The Negro Trailblazers of California* is a cornerstone of Black history in California. As a journalist, Delilah challenged the racial status quo in an era of casual racism and bigotry in her popular newspaper columns.

Her most important works documented the Black experience in California at a time when no one else cared about Black history or collecting and documenting the artifacts that would tell the story of the pioneering Black community in California. Delilah Beasley was a woman who was involved in her community and participated in many civic organizations. As a

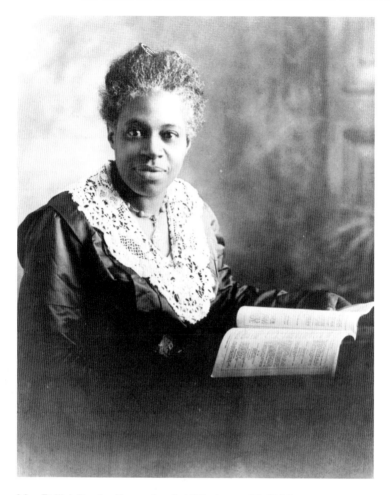

Mrs. Delilah Beasley (September 9, 1871–August 18, 1934), newspaper columnist, social activist and author of *Slavery in California*, the *Journal of Negro History* and *The Negro Trailblazers of California*. She was the force behind California's anti-lynching bill of 1933 and a member of the NAACP. *Miriam Matthews Collection, UCLA.*

member of the National Association for the Advancement of Colored People (NAACP), Delilah worked with local politicians, California state assemblyman William Knowland and assemblyman Frederick Roberts to introduce an anti-lynching bill. Delilah sought to make her community a better place for all people. Delilah Beasley passed away on August 18, 1934, leaving a legacy of historical facts that challenged the romanticized myth about the history of California that would conveniently leave out the contributions of the Black community. Thank you, Delilah L. Beasley.

MIRIAM MATTHEWS

Miriam Matthews, the first Black librarian in the Los Angeles Public Library system, was an expert in archiving and documenting the Black experience in California. Miriam was born in Pensacola, Florida, on August 6, 1905, the second of three children. Around 1907, her parents, Ruben and Fanny Matthews, moved to Los Angeles, California, where the family established a painting business.

After graduating from high school, Miriam enrolled at the University of California, Southern Branch, which would soon become known as the University of California–Los Angeles (UCLA). After two years of study in Los Angeles, she transferred to the Berkeley campus, where she graduated with a bachelor's degree in 1926 and received her certificate in librarianship in 1927.

After graduating, she returned to Los Angeles, seeking employment as a librarian in the Los Angeles Public Library system, something that had not happened for any other Black person. She was given the wrong date for the required civil service examination but was able to learn about the correct date and was able to pass the test. She started as a substitute librarian and soon became a full-time librarian at the Robert Lewis Stevenson branch library. After being transferred to the Helen Hunt Jackson branch library, Miriam began collecting artifacts and researching the history of the Black experience in California. She went back to school, studying library science at the University of Chicago Graduate Library School, where she earned a master's degree in library science. Upon returning to Los Angeles, she was promoted to regional librarian in 1949.

Miriam Matthews led efforts to establish what is now Black History Month

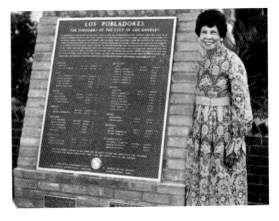

Miriam Matthews (August 6, 1905–June 23, 2003) is standing in front of the plaque honoring the founders of the city of Los Angeles. It was through her efforts that the plaque accurately depicted the race of the original settlers, indicating that more than half of the original settlers of Los Angeles were of African descent. She was the first Black librarian in the city of Los Angeles and established an unrivaled collection of artifacts and photographs depicting the history of Black people in California. *Miriam Matthews Collection, UCLA.*

but what started out as "Negro History Week" in an effort to inform the community of the contributions that Black people have made to the region. She fought against censorship in the library system and, in 1944, published a paper on "The Negro in California: An Annotated Biography." As Los Angeles was preparing to celebrate its bicentennial in 1981, Miriam Matthews served on the Los Angeles Bicentennial Committee's history team. It was her consistent voice that resulted in the monument to the original settlers of the city of Los Angeles listing the settlers by name, race, sex and age. This made it very clear that over half of the original settlers of Los Angeles were of African descent.

The Miriam Matthews Collection has over 4,600 photographs and other historic artifacts that document the Black community in California.

Miriam Matthews passed away on June 23, 2003, after having many honors and awards bestowed on her in recognition for her work in preserving the history of the Black community in California. The Hyde Park branch of the Los Angeles Public Library is named for her, and in 2012, she was inducted into the California Library Hall of Fame. But her legacy lives on in the collection that bears her name every time a researcher or scholar reaches back in time for information that Miriam Matthews has made available for generations to come. Thank you, Miriam Matthews.

AFTERWORD

As a youngster growing up in Southern California, I was not aware of anything that I would've called "historic" in the area. From the history books that I was reading at the time, all of the history of the United States took place on the eastern seaboard. The American Revolution, the War of 1812 and the War Between the States all happened in a far-off place that was known as the "East Coast." My first clue to the world of California history came on a ninth-grade field trip to the Manuel Dominguez Adobe in Compton, California. It was an eye-opening experience that let me know that there was more to California history than building a mission out of sugar cubes in the fourth grade. (I understand now that you can actually buy a model in the gift shop of any mission that you decide to visit.)

My next clue came in high school. My mother was teaching a class at Compton Community College, and in order to keep me out of trouble, she would have me accompany her to her evening classes. Since I was already on campus, I decided to enroll in a class. Okay, my mother really "helped" me decide to enroll in a class (on top of the high school classes that I had in the daytime). The name of the class was "The History of Mexico." It was quite an eye-opener, especially since it dealt with the Mexican-American War and the conquest of California and, before that, Texas. (Did you know that Mexico had a Black president in the 1820s who outlawed slavery?) Quite a different theme from what I was reading in my high school history books. Then I started learning about the Picos, Yorbas, Nietos, Tapias and other Spaniards of African descent who had received large land grants in Southern

California. This was getting interesting! I soon began to understand that I was surrounded by some of the most interesting history in the United States.

As a student at California State University–Long Beach, I had the opportunity to listen to lectures by Professor Arnett Hartsfield in which he described unsung heroes who fought discrimination and racism in Los Angeles throughout the twentieth century. I learned of the difficult fight to desegregate the Los Angeles Fire Department. I learned about legendary Black attorneys such as Burton Cerutti, Walter Gordon, Leo Branton, Thomas Newsome, Johnnie Cochran and many others. I heard about Dr. H. Claude Hudson and his dedication to the works of the NAACP in Los Angeles, and I learned of the accomplishments of Dr. John and Dr. Vada Sommerville, the first Black man and Black woman to graduate from USC's dental school. The Doctors Sommerville would also become leading voices in the call for equality. This was all eye-opening stuff!

I began to understand that history had been made all around me—I just was not aware of it. I began to understand that I was not taught local history, and it was very interesting. Just take the stories about Central Avenue and the community of Bronzeville during World War II—they would keep you fascinated for days. And there I was, a kid growing up in the 1960s in the city of Compton, California, thinking that nothing ever really happens here. I hope the readers of this book will become curious about the contributions of Black people in this state and find out more about the amazing stories, struggles and victories of the Black community in California history.

ABOUT THE AUTHOR

Robert Lee Johnson lectures on the subject of local history at colleges, universities and museums. Mr. Johnson is a member of the History Council and a past chairman of the Projects Committee at the California African American Museum (CAAM) in Exposition Park. He is a founding member of the Compton 125 Historical Society and has been recently featured in the documentaries *The Streets of Compton* and *Fire on the Hill*. Mr. Johnson is the author of *Images of America: Compton* published by Arcadia Publishing. He was formerly a leading member of the Compton branch of the Black Panther Party and a founding member of the Coalition Against Police Abuse (CAPA) in the 1970s. In the 1980s, he was a plaintiff in the notorious spying scandal that involved the Los Angeles Police Department's Public Disorder Intelligence Division (PDID).

.

Visit us at
www.historypress.net
...
This title is also available as an e-book